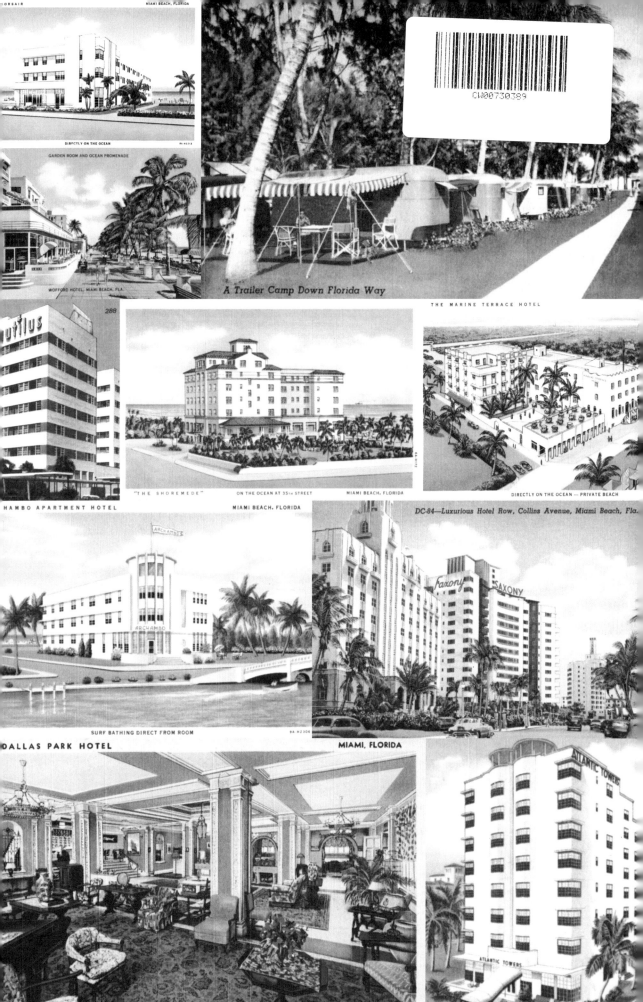

CORSAIR — MIAMI BEACH, FLORIDA
DIRECTLY ON THE OCEAN

GARDEN ROOM AND OCEAN PROMENADE
WOFFORD HOTEL, MIAMI BEACH, FLA.

A Trailer Camp Down Florida Way

CW00730389

THE MARINE TERRACE HOTEL

288

"THE SHOREMEDE" ON THE OCEAN AT 35TH STREET MIAMI BEACH, FLORIDA

DIRECTLY ON THE OCEAN — PRIVATE BEACH

HAMBO APARTMENT HOTEL MIAMI BEACH, FLORIDA

DC-84—Luxurious Hotel Row, Collins Avenue, Miami Beach, Fla.

Saxony SAXONY

SURF BATHING DIRECT FROM ROOM

DALLAS PARK HOTEL MIAMI, FLORIDA

ATLANTIC TOWERS

IN THE SPIRIT OF

MIAMI BEACH

To Barbara and Tom Rothchild—
Great people, great pals, and great additions
to Miami Beach.

© Text and personal archives: 2006, David Leddick
© 2006 Assouline Publishing
601 West 26th Street, 18th Floor
New York, NY 10001, USA
Tel.: 212-989-6810 Fax: 212-647-0005
www.assouline.com

ISBN: 2 84323 879 X
10 9 8 7 6 5 4 3 2

Color Separation by Luc Alexis Chasleries
Printed in Canada

All rights reserved.
No part of this publication may be reproduced, stored in a
retrieval system, or transmitted in any form or by any means,
electronic, mechanical, photocopying, recording, or otherwise,
without prior consent from the publisher.

IN THE SPIRIT OF

MIAMI BEACH

WITH PHOTOGRAPHS BY
ETHAN WINSLOW AND PETRA MASON

DAVID LEDDICK

ASSOULINE

CONTENTS

The swimming pool at the Standard Hotel on Belle Isle.

INTRODUCTION

BY DAVID LEDDICK

Miami Beach is a kind of dream. Imagined as a dream. Built as a dream. And today this dream has been reawakened and has become an ever-larger dream. Where will it end? Will Miami become the New York of the twenty-first century, the linchpin city between the Northern and Southern hemispheres of our side of the world? With Miami Beach as the equivalent to New York's Upper East Side: posh, expensive, rare, and difficult to find residence in? Or will Miami Beach continue to become the grandest of all resorts in the United States?

What is a reality is that Miami Beach is the temporary residence of those with the most money, the most talent, the most beauty and, most importantly, the most nerve. For audacity is one of the city's essential qualities. If you don't have the nerve for the dizzying apex of glamour, the nerve for the speediest of all speedy fast lanes, the wit and the footwork to stay standing while the sun-drenched fun fair whirls about you, perhaps it would be best to stay home. Or choose somewhere more staid like, say, Palm Beach for your holidaying.

I first encountered Miami Beach in 1979 during one of its downturn periods. I was in Fort Lauderdale preparing a television commercial for Revlon which would link the cosmetics giant to the Olympics and to female athletes. It was midwinter in New York and we had to head south. Fort Lauderdale appeared to be the most southerly destination where sporty American girls could be found in large supply. Miami Beach would be unthinkable, filled as it was with retirees, most of European origin.

Our director was Eddy Vorkapich, Hollywood-born and bred, the son of a well-known director of special effects. It was Eddy who suggested that we go to Joe's Stone Crab in Miami Beach for dinner. He spent much of the winter in the South and knew where to dine out. I remember so well driving down Collins Avenue in the dark of early evening. A bank of high-rise buildings to the left obstructed the ocean view.

And as we made our way farther into the heart of old Miami Beach, a section now known as South Beach, on the right-hand side were front porch after front porch of formerly glamorous 1930s hotels, each crammed with rows of elderly people seated on folding aluminum chairs under the harsh illumination of fluorescent lights. It was uncanny. Absurd. Deathlike. The effect was of rows of gray corpses waiting in some kind of departure lounge, a feeling made stranger by the warm, sensual sea breeze blowing and the smell of flowers in the air.

At Joe's Stone Crab there was another wait, a forty-five-minute one, on a line outside. No reservations were—or are—possible at Joe's, although these days a hefty tip to the maître d' can sometimes hurry up the process. Our camera crew liked the stone crabs and I liked the fact that the crab is relieved of his one big claw and thrown back into the ocean where he can grow a new one for the coming season.

We drove back, passing rows of the elderly onlookers gaping into the velvety blue moonlight that is so unique to Miami Beach. The knowledge that the first discovery of romance was but a memory to them hung as heavily in the air as the scent of the frangipani blossoms.

A few years later I returned to Miami to make a television commercial for a popular Revlon shampoo. Guess what? It involved a lovely blonde with great

The Avalon Hotel on Ocean Drive.

hair running on the beach. Key Biscayne, the southern cousin of the giant sandbar that is Miami Beach, was chosen as the location.

We stayed in a rather conventional hotel in Key Biscayne and dutifully filmed our blonde cavorting on the sand, pursued by a handsome dark guy we had cast in Miami. His looks alone suggested that we were somewhere a little more exotic than New Jersey.

In the local paper I read that it was Art Deco Weekend in Miami Beach and I insisted that the crew make a visit while we were in town. In the daylight I was able to see the many ranks of Art Deco buildings in Miami Beach, and I enjoyed a modest street fair that ran along Ocean Drive between the beach and such hotels as the Carlyle, the Cardozo, the Clevelander, and the Tides. The Carlyle had been renovated and had a Deco-style bar. The Cardozo had a small restaurant. And that was about it. But there were painters, writers, actors, and dancers; performing, discussing, and relishing a bohemian life-style that had obviously just sprung up among the neighboring hotels still catering to the elderly. I loved it.

I decided I had to buy a small apartment in what was then called the Deco District. And I tried. I really did. I called realtors. I made appointments. I flew back to Miami Beach, stayed at the Carlyle, and was shown one or two dreary places near the Deco District by real estate agents who were clearly bewildered as to what I wanted and why I would want to live there. They kept trying to interest me in the Bal Harbour area to the north. "So much nicer," they said. I threw in the towel.

However, a few months later I read an article in *Esquire* magazine about the revival of Miami Beach and a name was mentioned: Barbara Capitman. She was the president of an organization called the Miami Design Preservation League. She had managed to get the Deco District a designation as a protected architectural area. It was the only such area of twentieth-century buildings in the United States, all the others being of earlier periods. I called Barbara, who suggested I call the realtor Susan Rothchild. "She'll know what you are talking about," she said.

I returned to Miami Beach, and this time it took. Susan Rothchild was a good-looking redhead in high heels who walked in a "Watch me" kind

of way, and she and I soon realized that although some of the hotels might be transformed into condominiums, no such thing yet existed. We turned our attention to small, going-to-hell buildings. And there, lurking behind the Adrian Hotel just off Ocean Drive was a little Bauhaus-style building. Very dilapidated—its three floors held seven worn-down apartments—but affordable. I bought it.

Among my new friends in Miami Beach was Leonard Horowitz—Lenny— an interior and exterior designer who was a cohort of Barbara Capitman's. It was really the two of them who had reenergized the Deco District of Miami Beach. Barbara did the talking, and Leonard did the design schemes for the repainting of the buildings in wonderful combinations of colors, now recognized as the Miami Beach look. The television series *Miami Vice* would have been remarkably unstylish if its creators hadn't had Leonard's color combinations to draw upon. Barbara and Leonard were an eccentric pair, full of daydreams that, as much to their surprise as anyone else's, came true. They talked up glamour, and painted the buildings with almost a "Potemkin Village" effect. And they waited until the day that renovators would come and actually make all these buildings into what the quick paint jobs suggested they were. I remember being with Barbara at the Carlyle bar, where she fell asleep with her head on the table. A few days later, she accosted me on the street. "I hear you are telling people I fell asleep on a table in the Carlyle bar." she said. "Didn't you?" I said. "Well, yes," she replied. "Barbara, you can hardly fall asleep at the Carlyle bar and not expect people to talk about it." I told her. That was the raffish Miami Beach world of that time.

Wonderful Leonard Horowitz, who resembled in many ways a chatty penguin, visited me in France soon after that and disappeared in the French country town where I lived. After a long time, he reappeared and said, "Not only have I never seen a village like this, I didn't even know there were villages like this!" Leonard, years later, died of AIDS. There's a short length of street named for him near that first house I bought in Miami Beach. No one seems to remember his contribution now. I miss him.

My plan was to be a good citizen and to renovate my building and leave all my tenants in place, with me occupying only the penthouse on the top

floor. But it soon became clear that this would be impossible. The shower on the second floor drained directly into the back first-floor flat. The front first floor flat had no electricity. The one room in the penthouse that I had never seen had a good reason to not be shown: there was a hole in the roof that a bathtub could fall through. The former owner had left closets full of clothes in that room. They were all soaking wet. Still sopping wet from the hurricane season that had ended some four months earlier.

Unfortunately, all the tenants had to leave while the building was pulled apart internally to replace the plumbing and electricity. A Dumpster was placed in the street, and it was quite a thrill to throw in wet clothes, broken toasters, and one-legged chairs from the upper balconies. There were a series of truly satisfying thumps and crashes.

A sizable apartment emerged from the renovations on each floor. What became the bathroom on the second floor had originally been one of seven apartments. There had been a lot of jerry-built plumbing and electrical wiring forced into this old building all of which had to be replaced. It had once been a doctor's vacation residence, I was told by a woman who spent her childhood summers in Miami Beach. "It was here before any of the hotels," she said. Built in 1925, my building might well have been the first Bauhaus-style structure in the United States since that German Moderne style was introduced to the world in that same year.

With Leonard's advice, the building was painted white, its supporting pillars black, and the winding corkscrew staircase on the front corner a fire engine red. It looked great and received a national prize for the best Art Deco restoration of 1985 from the National Architecture League. I had a plaque put on the front. It was called "The Leddick House." Imagine my pride now all of this has been swept away as the Design District has morphed into South Beach.

I finally sold my house and moved to a quieter spot in Miami Beach for the simple reason that it became impossible to sleep there. Nightclubs proliferated. The neighbors and I convinced the city of Miami Beach to pass its first noise control laws, but it became clear that the elderly residents and I were all going to have to give in. Some of us moved on to Heaven, and others to more

heavenly parts of Miami Beach. Since then I have lived on Royal Palm Avenue (quite heavenly), and Flamingo Drive—not to be confused with Bette Davis's great movie *Flamingo Road* (1949). Remember that? She enters, looks around and says disdainfully, "What a dump."

Well, you can love a dump. Flamingo Drive, the second-best street in Miami Beach, was anything but, though I have to admit that North Bay Road does it one better. And now I live on the Venetian Islands, that enchanting necklace of small islands that stretches from Miami Beach to the mainland. They stand where the original wooden bridge reached across the bay on the shallows between the city and the beach. It was blown away in the hurricane of 1925. Miami Beach is the kind of city where when something gets hurt, it roars backs and becomes something better.

The newest homes and residences in Miami Beach owe little to the styles or spirit of the past. Here there is rarely an attempt to recapture the look of an English country house, all chintz and too much furniture. Nor is there any great attempt to recapture with exactitude the Art Deco look of the 1920s and 1930s.

Contemporary designers may be inspired by the purity of the Deco period and the surrounding buildings of Miami Beach, but the look has far more to do with the expression of personalities who do not relate to the past but are instead firmly looking forward. The world they inhabit is new, and they want their homes to reflect the air and the space and the cleanliness that surrounds them.

Now, when I ride my bicycle through South Beach, it is something of an enchanted dream come true. Building after building that was once crumbling, hesitantly still beautiful but almost ready to fall into dust, has not only been repainted but also rebuilt and restored, provided with splendid kitchens and bathrooms, snuggled into lavish boas of flowering greenery, and shaded with giant palms. It is truly unbelievable that a city built on a sandbar with no long-range plan, but with all the enthusiasm and effervescence of the 1920s, has blossomed again. Here's a town that never had a respectable, puritanical, penny-pinching past. From the beginning, it was a place for high rollers, big spenders—and chance takers.

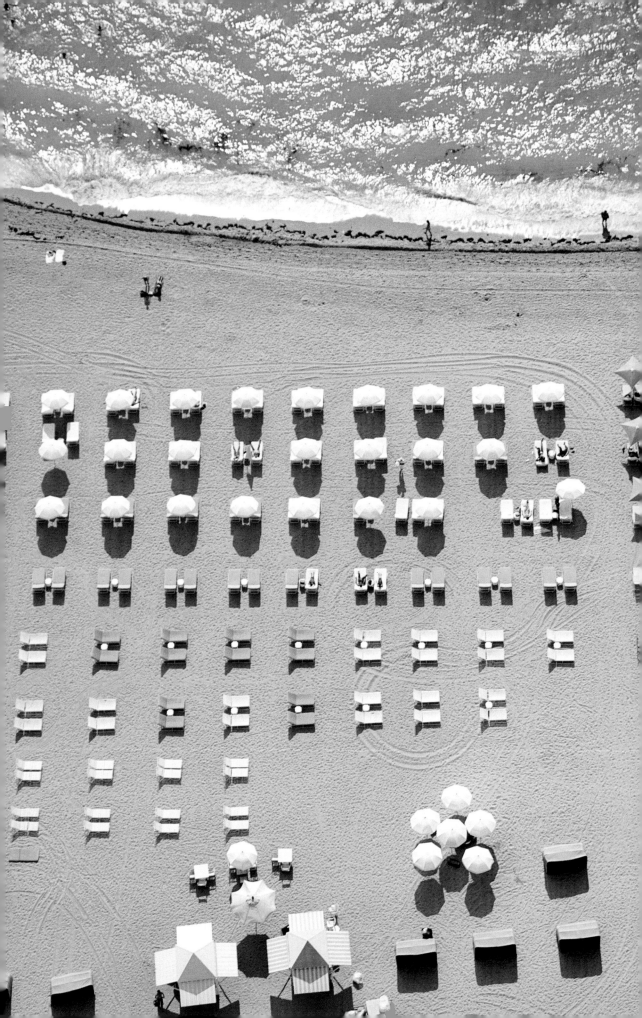

I had a cousin who was a chorus girl in Miami Beach in the late 1930s. Actually, she was an Albertina Rasch girl. A member of one of the numerous chorus lines that Albertina Rasch would cast, choreograph, and send to Broadway shows, nightclubs, and theaters across the country to romp about in and do their high kicks. When my cousin heard I was now living in Miami Beach, she immediately asked, "Is the Villa Venice (pronounced to rhyme with 'fleece') still on the beach at 15th Street? I was in the line there." The Villa Venice eventually moved to Star Island where it stood next to Lou Walters's Latin Quarter—a club that later found even greater fame in New York, as did Lou's daughter Barbara Walters.

Now I wish I had asked my cousin more about the Villa Venice. What were the dressing rooms like? Who rehearsed the girls? How big was the band? Was there a gambling room upstairs? There had to be. Whom did she go out with? My cousin went on to become a showgirl at Billy Rose's Diamond Horseshoe in New York during World War II. She married a military officer and later became the wife of a major league advertising executive. (These were the same man.) She was part of the great glamour that has always been the world of Miami Beach. And now on to the details, some past and some present.

Opposite: Lounge chairs and umbrellas on Miami Beach.
Following pages: A contemporary map of South Beach.

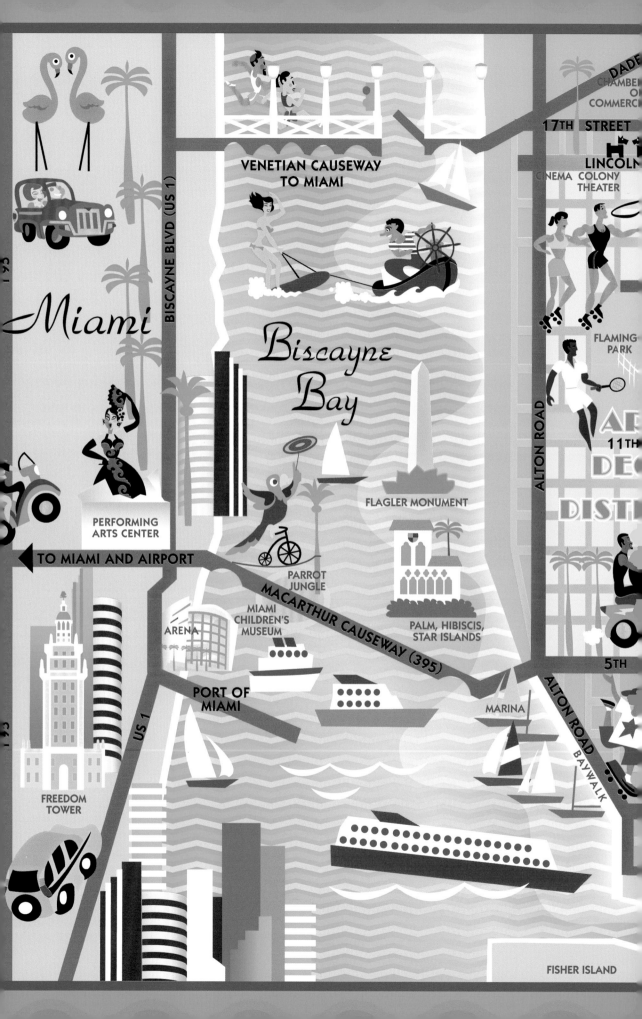

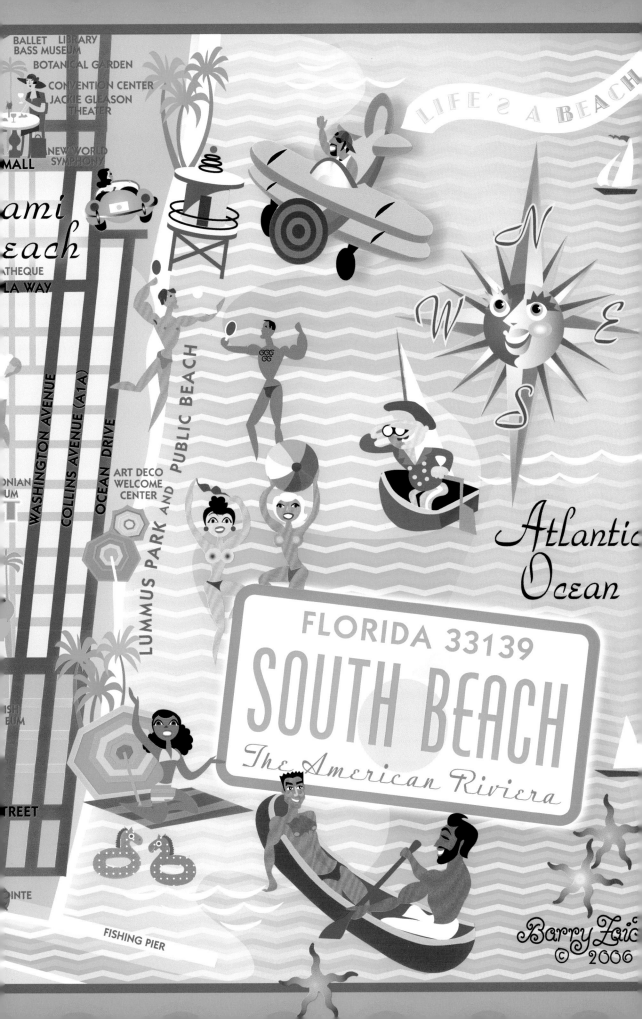

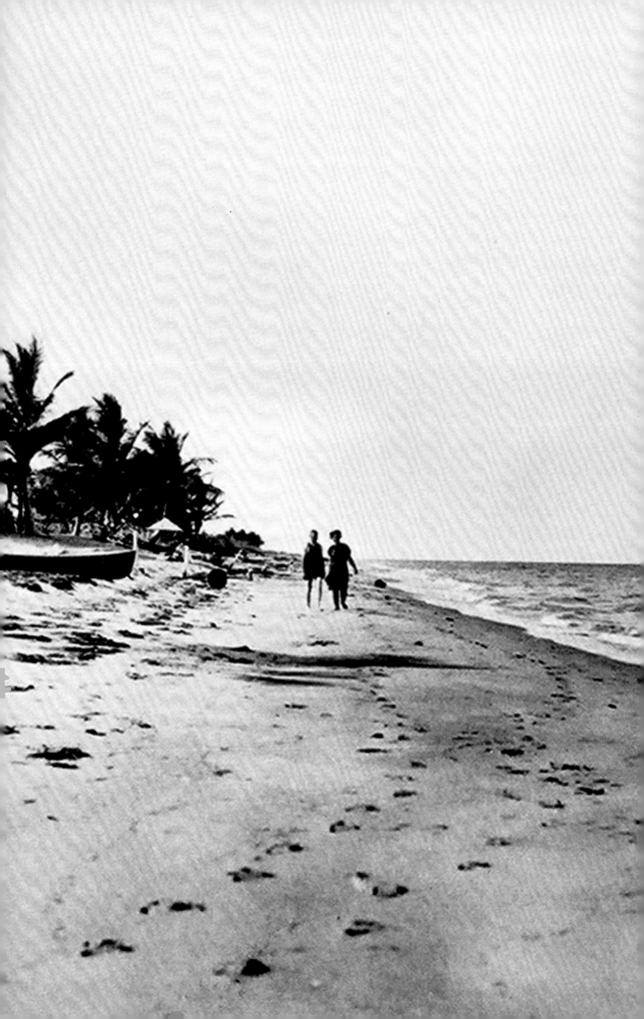

IN THE BEGINNING,
THERE WAS SAND

Stating that Miami Beach is a city built on dreams may be banal, but you can certainly say that it has been built on unreality. Today Miami Beach is an island. Once it was a peninsula. Where there was once water, now there is sand. Where there was once sand, now there is water.

Miami Beach has been whirled together with something like a magician's hand. Over the years, hurricanes have cut waterways across the sandy strip. And waves have silted up Indian Creek, which rambles down the center of Miami Beach and is the beginning of the inland waterway that stretches along the Atlantic Coast. Another hurricane, geographers say, resulted in the large opening between Miami Beach and Key Biscayne in 1838.

The earliest map of Miami Beach was drawn in 1765, during the brief period when the English owned Florida. They had exchanged it for Cuba, which they had previously owned. What is now Fisher Island was part of Miami Beach. You could walk there. And there were islands in the bay— none of which are the same today; our islands are now all man-made. The English had exchanged it for Cuba with Spain. In 1771 a second map by surveyor Bernard Romans showed the beach in more detail. Indian Creek emptied into the ocean at that time. The British returned the territory to

Opposite: Miami Beach, ca. 1910.
Following pages: The Atlantic Ocean at 21st and Collins Avenue.

Spain in 1784. An 1839 map clearly shows that another cut had been made through the beach by storms that separated it from what is now called Virginia Key. It is known that there were severe hurricanes in 1835 and 1837, which must have made the opening. Miami Beach belonged to the United States by this time, Florida having become a territory in 1821 and a state in 1845. By 1876, a life saving station was being manned on the beach.

Miami Beach was shifting about long before anyone but the Tequesta Indians were living here. It has remained easily changeable, restructuring itself according to people's dreams. The Tequesta burial mounds on Miami Beach have surrendered bones that suggest the presence of inhabitants for more than 3,000 years. There are also bones which imply that Spanish sailors were shipwrecked here. And because of these frequent shipwrecks, one of the first structures was called the Biscayne House of Refuge. It was built rather late, in 1883, and was a tidy little cottage with three rooms and a kitchen downstairs, a loft with beds for eight, and a very quaint porch on three sides; almost luxurious after having been shipwrecked.

Miami Beach's internationalism and multilingualism dates back even further. Many a ship went down along its coast when the Spanish were transporting their silver and gold loot from the New World. The first markings along the coast included signs in English, French, and Spanish, indicating where fresh water wells were located—wells that had been dug for the survival of those who had escaped from wrecks in these waters. Some early Miami-area settlers came from the English-inhabited Bahamas and were frequently accused of putting out signal lights and luring ships ashore. One of these settlers, a man named Brama, may have occupied a hut on the beach as early as 1861. Named after him, the place was variously called Bremon's Landing, Brama's Landing, and Brahman's Landing and may have been on what is now Fisher Island. And even that was only some 150 years ago.

In 1870 a man named Henry Lum wandered onto the beach. Seeing a few stray coconut trees, he decided to buy land to create a palm tree plantation. He struggled, but the rats, rabbits, and raccoons got the best of him. And then two brothers, confusingly named J. E and J. N Lummus, appeared and started developing the same land.

Workmen measuring the depth of Biscayne Bay in preparation for new islands, ca. 1923.

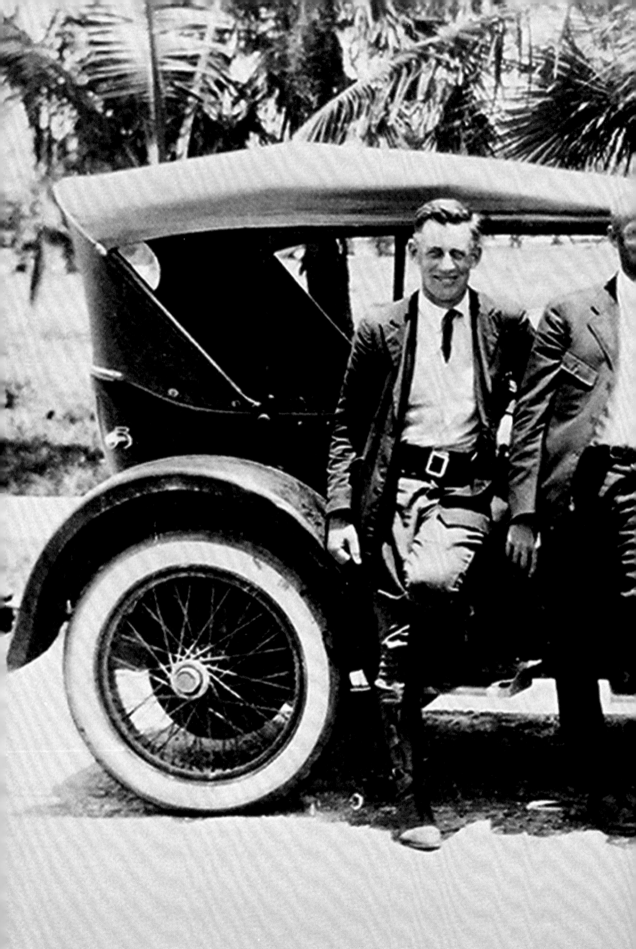

Chief of police Brogden and the entire Miami Beach police force, May 19, 1921.

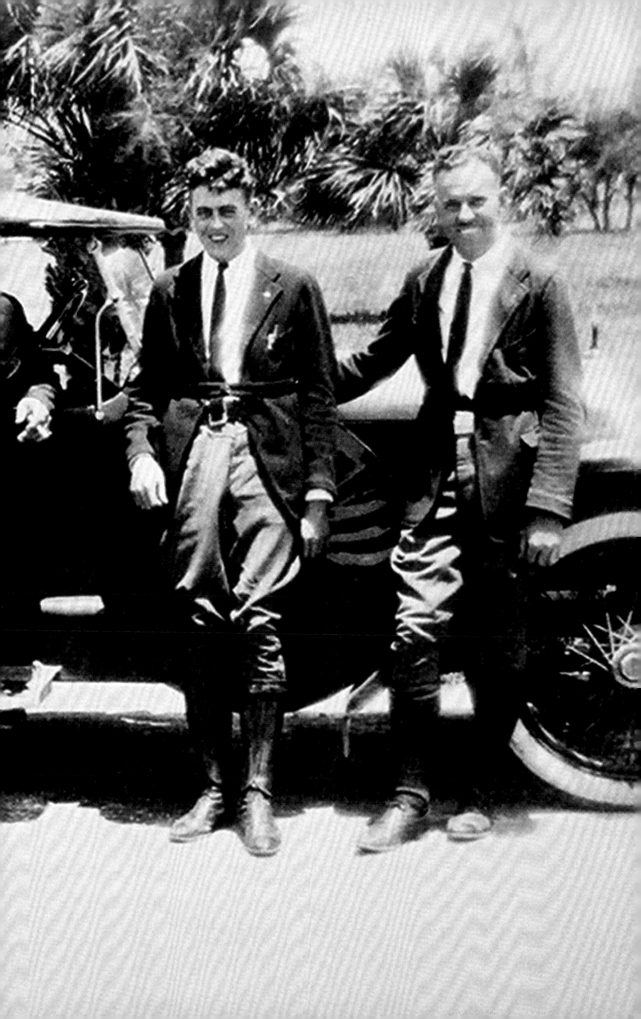

In 1909, a self-made, wealthy horticulturist named John Collins arrived and, more successfully, started avocado groves. At the time, Pine Tree Drive was actually planted with Australian pines to provide shelter for Collins's sea-wind-battered plants. His son-in-law, Thomas Pancoast, was the only family member among his sons and daughters to help him out when he got over his head financially. Nice family. But once it became clear that Miami Beach had a future as a resort, they all pitched in, buying up stretches of beachfront property. These are the early names that crop up in Miami Beach: Lummus, Collins, Pancoast.

But none of them stacked up against the extraordinary Carl Fisher. Carl was from Indiana. He quit school to sell candy on trains and there was no stopping him. He loved cars, he loved competition, he loved anything modern. He helped invent Prest-O-Lite, the first serious acetylene lamps for automobile headlights, the replacement for kerosene lanterns, which tended to blow out when cars gathered speed. Fisher's invention blew out quite a few windows in Indianapolis before it was perfected, but he eventually sold his share for $9 million. That was a whole lot of moola in 1907.

Fisher then built the Indianapolis Speedway and married a 15-year-old. He was 35. Both projects were successful. He came to Miami because, after a failed yachting trip in the Gulf of Mexico one winter, his captain sailed his boat to Jacksonville to ship it north. Stopping in Miami, the captain wired to him, "Meet me in Miami instead of Jacksonville. Nice little town."

Fisher hit town doing a hundred, and in the next ten years Hurricane Carl completely changed Miami Beach. At that time, the Collins/Pancoast families were engaged in building both a canal across Miami Beach and a wooden bridge to the mainland. They needed money. Fisher invested and took land as equity. He loved speedboat racing, so he cleared his land into lots facing the bay, built huge seawalls, pumped his swamp full of sand and subdivided it. The new owners would be living on a boat raceway. Fisher then knocked Lincoln Road through the jungle and built a palatial home where it met the ocean. It was called the Shadows. All part of that dream, obviously.

Right behind his home, Fisher built glassed-in tennis courts and a polo ground. It didn't take him long to figure out that the new Midwest moneyed

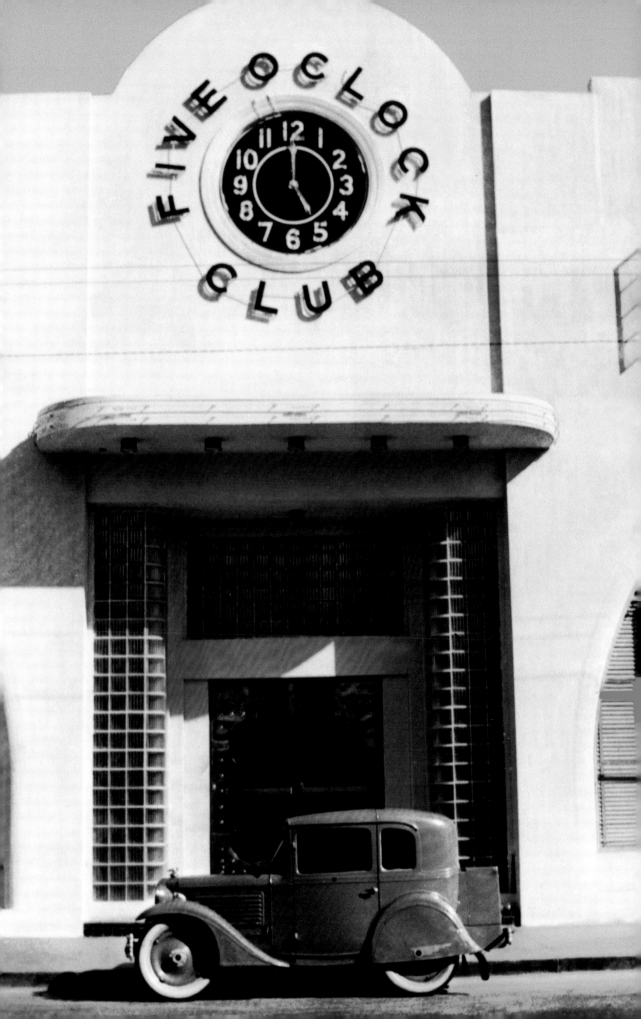

class, not too welcome in Palm Beach, needed someplace to spend its dough. Fisher had been responsible for conceiving and pushing into existence the first coast-to coast highway. He reasoned that you weren't going to sell cars if there was nowhere to drive them, and convinced the automotive companies to put up much of the $10 million necessary to build the new thoroughfare. It became the famous Lincoln Highway. Next he cooked up the Dixie Highway, which began up in Michigan and followed two routes south, both ending up, naturally, in Miami. He instituted speedboat regattas to thrill the increasing crowds of tourists and encouraged his wife to go swimming in an abbreviated suit without stockings. Imagine!

Although there were luxurious hotels in Miami, there were still only three small places to stay on Miami Beach, so Carl Fisher built the fabulous Flamingo Hotel. It stood near where 15th Street met the bay and was designed by an Indianapolis company with the unusual name of Rubbish and Hunter. (No comment.) He rushed six gondolas into construction in twenty days and wrote to a friend, "I have some of the most wonderful Bahama negroes you ever saw to push these gondolas around. They are all going to be stripped to the waist and wear big brass earrings. And possibly necklaces of live crabs or crawfish." Why Carl Fisher never made it to Hollywood is a mystery. It sounds like he certainly was no stranger to chemical mood enhancers. And this was a man whose land contracts forbade anyone black to buy property he owned.

The Flamingo, with its giant dome in which colored lights played at night, became an immediate landmark. Carl made it clear who was boss around Miami when he stole President-elect Warren G. Harding right out of the welcoming arms of Miami's mayor and installed him at the Flamingo. He lured him down to his fishing camp, the Cocolobo Club, and then got him to take a dip in his Roman Pools. The president said, "I hope to come here again. This beach is wonderful. It is developing like magic." Fisher knew all there was to know about public relations: the president of the United States had just set him off on the wild ride of the 1920s.

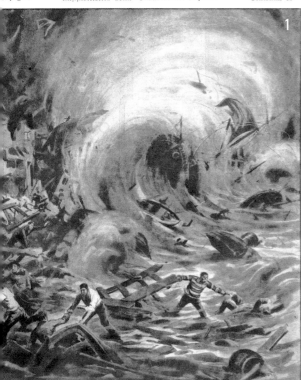

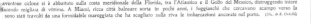

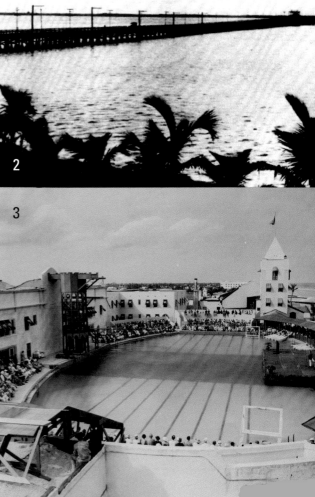

aventoso ciclone si è abbattuto sulla costa meridionale della Florida, tra l'Atlantico e il Golfo del Messico, distruggendo intere
facendo migliaia di vittime. A Miami, ricca città balneare sorta in pochi anni, i fuggiaschi che cercavano scampo verso la
sono stati travolti da una formidabile mareggiata che ha scagliato sulla riva le imbarcazioni ancorate nel porto. (Dis. di A. Ortelli)

1. The cover of an Italian picture magazine depicting the Miami hurricane of 1926.
2. The Collins Bridge, the world's longest wooden bridge in 1912 and the first bridge to the mainland.
3. The pool of the Macfadden Deauville Hotel at 67th Street.
4. Postcard of the Roney Plaza and Indian Creek.

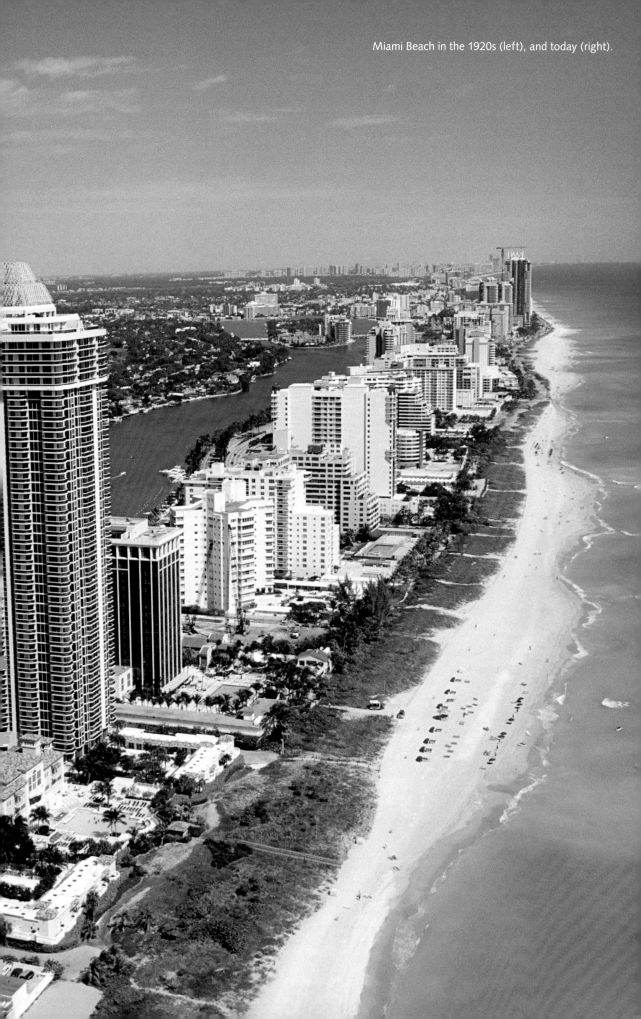

Miami Beach in the 1920s (left), and today (right).

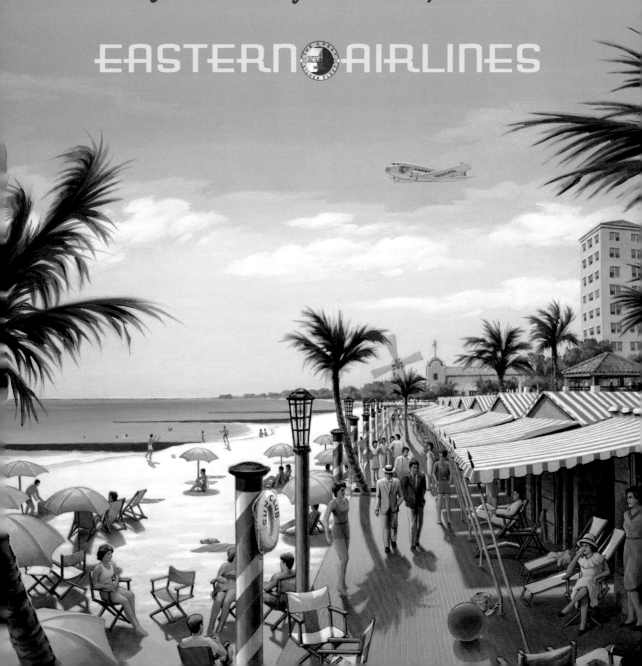

Miami Beach
FLORIDA

Just 10 hrs from New York

EASTERN AIRLINES

ENTRE LES GUERRES: THE 1920S & 1930S

Miami Beach has had an almost uncanny tradition of previewing what the rest of the country discovers slightly later. The boom that America would enjoy in the late 1920s happened in the early part of that decade on the beach. Miami Beach's boom went bust in 1926, because of a catastrophic hurricane, the likes of which had never been seen in the history of the inhabited city. And then when the national business crash came in 1929, Miami Beach hardly noticed it and sailed into the 1930s with more and more people, more and more buildings—and more and more money. Historians do not record this but Miami Beach has had a past quite different from that of the rest of the country.

Carl Fisher, with his imagination and knack for making money, continued the transformation of Miami Beach as the 1920s began. Another luxurious hotel was built, the Nautilus, this time just above 41st Street. Built in the lavish Spanish Baroque style, Fisher wanted audiences for the speedboat regattas and sailing activities in the bay.

In 1949, the hotel was purchased by the Miami government for $20—one dollar a year paid out over twenty years—and later that year, the hotel was converted into the Mount Sinai Hospital.

A poster advertising aviation travel to Miami Beach in the 1930s.

At the same time that the building boom was going on, Miami Beach was home to the largest mango and avocado orchard in the world. John Collins's groves were producing tons of fruit to be sent north in the wintertime. These trees stood along the ocean on 160 acres of land. Their position doomed them. Now millionaires wanted beachfront estates and the mangos and avocados weren't worth as much as the land they stood on. The groves went down, and the houses went up. On the waterfront on both sides of Miami Beach, names like Firestone and Gould were building their mansions. This was the second phase for Miami Beach and perhaps its most glamorous.

The wealthy had their polo ponies and yachts sent down for the winter. Private beach clubs like the Surf Club and the Bath Club were founded so members would not have to mingle with the masses at the Roman Pools and other popular hangouts. The La Gorce Golf Club added a second course to the city, and tournaments were held each winter. Big names like boxing champion Gene Tunney, Ziegfield Follies star Will Rogers, and flying ace Eddie Rickenbacker came to visit. Miami Beach was becoming the place to go. A lot of it was about transportation. Trains brought inhabitants down in a jiffy from New York in the winter, and the automobile made it easy to show up from all over the country. Miami Beach introduced the idea of glamour to North America, and everyone ate it up. It was the first time in the history of the United States that it was all right to take off most of your clothes, it was all right to be beautiful, it was all right to live for the moment. And Miami Beach was the place to do it.

Carl Fisher was given a run for his development money by a new personality, N. B. T Roney. Some people said the initials stood for "Nothing But Trouble," but most people called him Newt. Roney saw dollar signs in everything. A stretch of land on the ocean just above 23rd Street had stood empty, with developers hoping someone would build a hotel there. Roney did, a great pile dripping with stone carved in the Spanish Baroque style.

His eponymous, gigantic fantasy hotel, the Roney Plaza, enjoyed enormous success. If you wanted glamour, you could get it at the Roney with its tea dances, dinner parties, and promenades crammed with women covered in furs and jewels and men in panama hats, double-breasted blazers, and the

George Gershwin at the Roney Plaza Hotel's Café de la Paix in the 1930s.

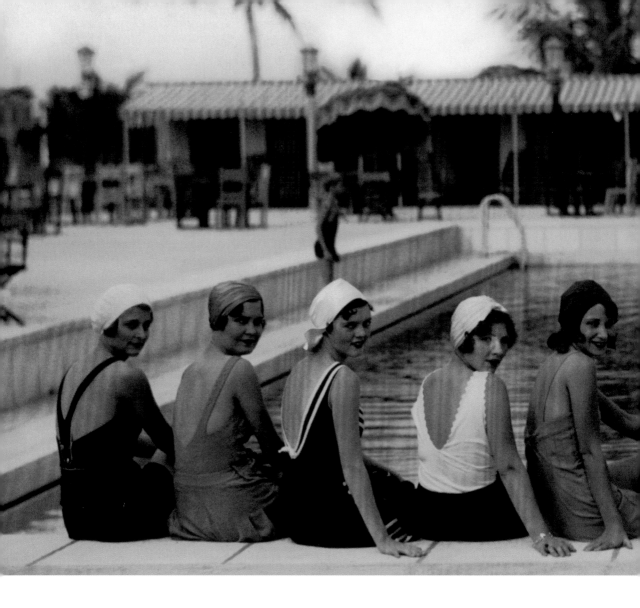

new "plus four" pants for men, which fastened below the knee and which were worn with high socks. The trousers were created for golf but were worn everywhere, especially in Miami.

Transportation to the beach was facilitated by the new causeway down at 5th Street and by the Venetian Causeway, which stretched across a series of islands that had been dredged from the bottom of the bay and dumped in place, to replace the original wooden bridge. There were plans to virtually fill the bay with these man-made landfill islands. However, they were found to interfere with the movement of water and wildlife, and few were created after the Venetian Islands. People were feverishly buying up lots on speculation and reselling them. Speculators were buying from speculators,

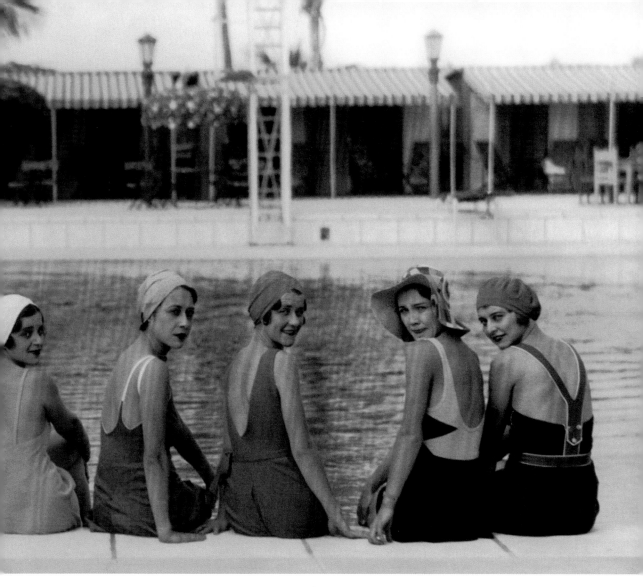

Bathing beauties at the Roney Plaza Hotel in 1937.

and antipathy began to grow towards these businessmen, who were running around town in their plus fours, making money hand over fist. The boom was already weakening as the 1926 season began to come into view.

In September, the bottom fell out. Or, rather, it was swept away. Hurricane warnings were put up at eleven o'clock on the morning of September 17, and early the next morning the storm struck. At dawn, people began to leave their homes, not realizing they were in the eye of the storm. It struck again and caught many people in its fury as they struggled to return to safety. Some didn't make it. At least 114 people died in the Miami area alone, and thousands had to find new homes or rebuild their old ones.

BOUCHE

VILLA VENICE

AMERICA'S SMARTEST THEATRE RESTAURANT

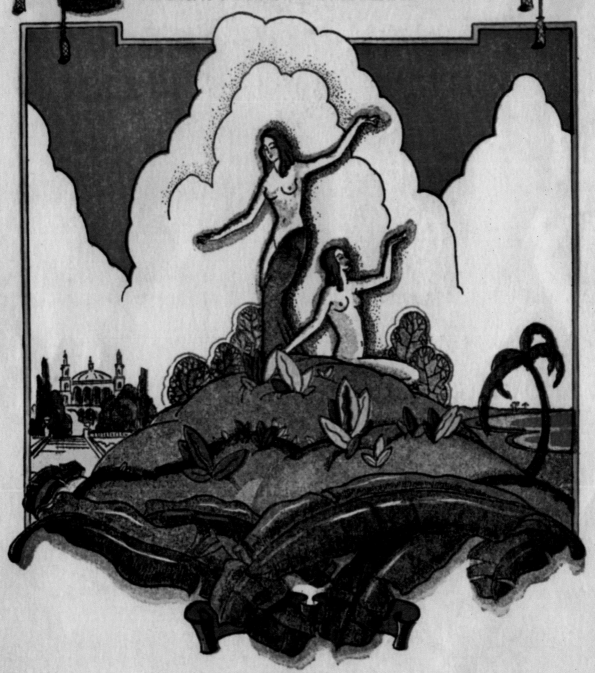

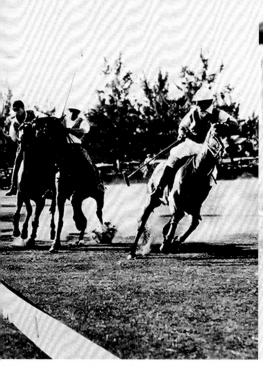

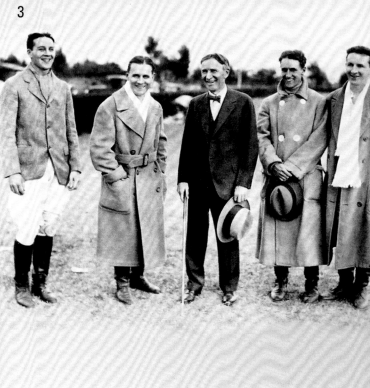

1. A menu cover for Papa Bouché's Villa Venice.
2. Carl Fisher (right) and fellow players, 1922.
3. Harvey Firestone and his polo-playing sons, 1929.
4. A polo team lines up in front of the stands, 1919.

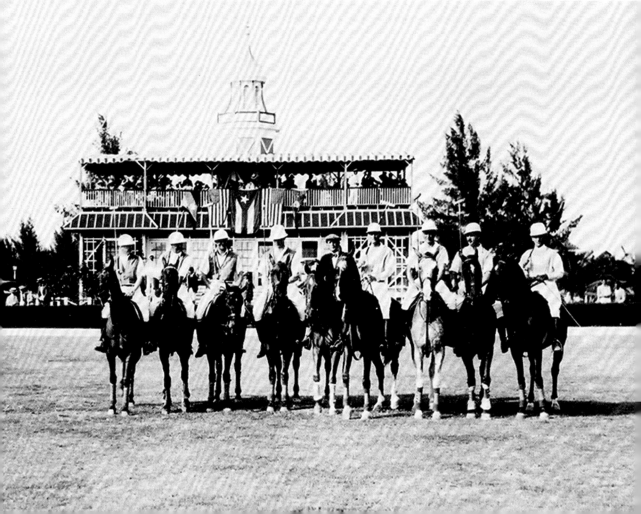

Miami Beach was devastated by the hurricane of 1927; tourism didn't even exist that year. Al Capone arrived, and business slowly began to recover in 1928 and 1929. The economic crash of 1929 slowed it down again, but Miami Beach fought its way forward. The Bath Club opened in 1929, and the Depression was pretty well ignored by its members. Despite their losses, the millionaires still had some millions to spend.

By 1933, Miami Beach was successfully rising above the Depression. Its 1920s reputation as a playground for the wealthy made it attractive to working class people, who could drive down or take a train to Florida. There they could cram sun, sea, and sand into a vacation of a few weeks, or even a few months, on a low budget. They came in crowds and brought millions of dollars to the area.

Even though the rest of the country was pinching pennies and worse, new Art Deco-style hotels were being put up all over the southern part of town, in the section we now call

The Surf Club, ca. 1930s.

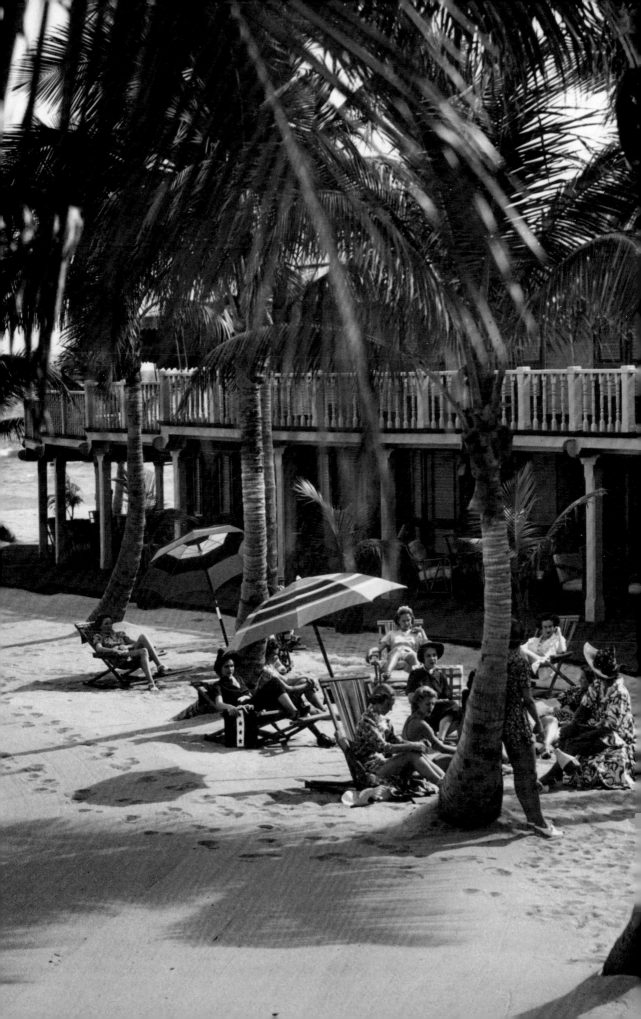

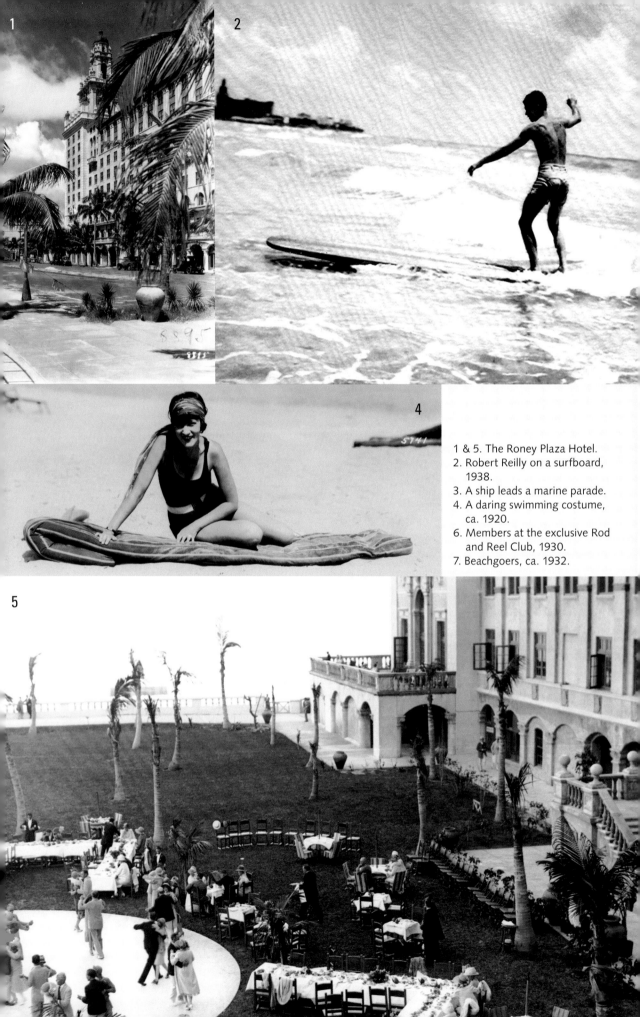

1 & 5. The Roney Plaza Hotel.
2. Robert Reilly on a surfboard, 1938.
3. A ship leads a marine parade.
4. A daring swimming costume, ca. 1920.
6. Members at the exclusive Rod and Reel Club, 1930.
7. Beachgoers, ca. 1932.

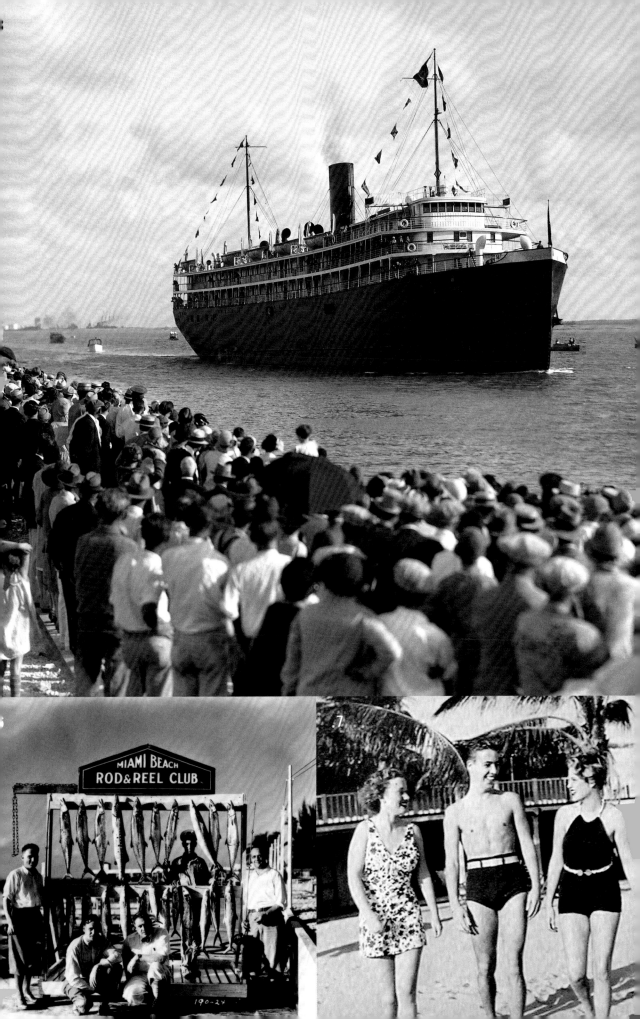

South Beach. The lavish Spanish Baroque style gave way to a look that owed much to shipboard design, with curved walls, portholes, railings, and balconies. The airplane, too, lent design to this new style: streamlined and sleek. An innovative form of transportation for the rich, images of the airplane were everywhere.

Gambling was probably the biggest reason Miami Beach survived so well in the 1930s. In the early part of the decade, Prohibition was still in force and many hotels and nightclubs had secret rooms where drinks and gambling tables were available. Thrill seekers could also find three racetracks and omnipresent slot machines, all legal in Florida.

The governments of both Miami and Miami Beach were considered rather corrupt, and there was little effort to control crime. Miami Beach boasted sun and fun, and most of the fun was to be had in illegal casinos. Two casinos owned by George R. K. Carter were built at the tip of the beach on a long, L-shaped pier. The casinos each had fifteen roulette wheels, seven or eight craps tables, and games of chemin de fer, baccarat, wheel of fortune, and faro. Money was pouring into Miami Beach. Vice was paying off. When Carter left, the Minsky Burlesque moved in from New York bringing with it girls, girls, girls!

Soon after the notorious Al Capone arrived, he pushed his way into the upscale Park Island Club, the gigantic Fleetwood Hotel's Hangar Room, and the flashy Villa Venice nightclub. The Deauville Hotel casino had to hire its own gangsters just to keep him out.

Romance also played a big role in the popularity of Miami Beach in the 1930s. After the fast and furious 1920s, the 1930s were all about wearing floaty dresses and tuxedos under a tropical moon. Women imagined dancing in someone's arms to the swooning music of the big bands. It was the Fred Astaire and Ginger Rogers moment in Miami Beach, an ideal place to make a trip for some much-needed love. In 1935, *The New York Times* reported: "…it doesn't feel much like the rest of the nation."

Carl Fisher (right) and Dan Mahoney playing golf, 1927.

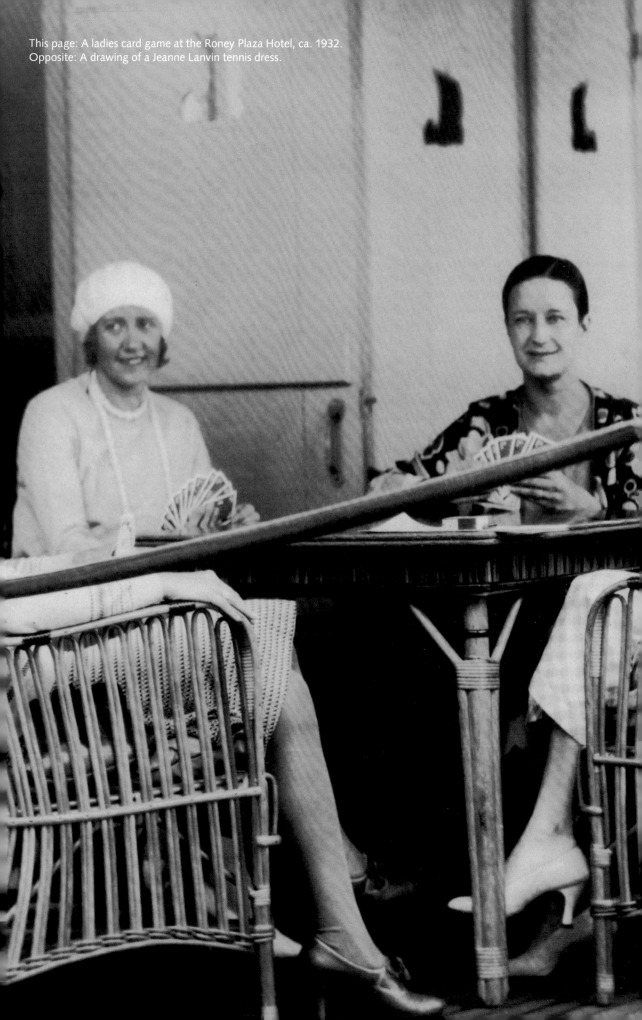

This page: A ladies card game at the Roney Plaza Hotel, ca. 1932.
Opposite: A drawing of a Jeanne Lanvin tennis dress.

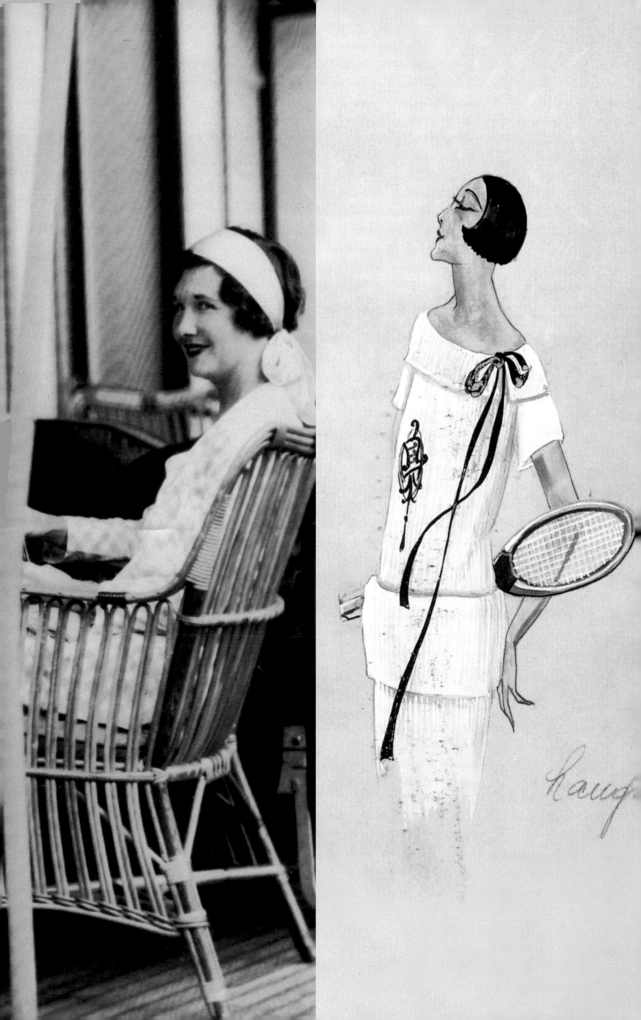

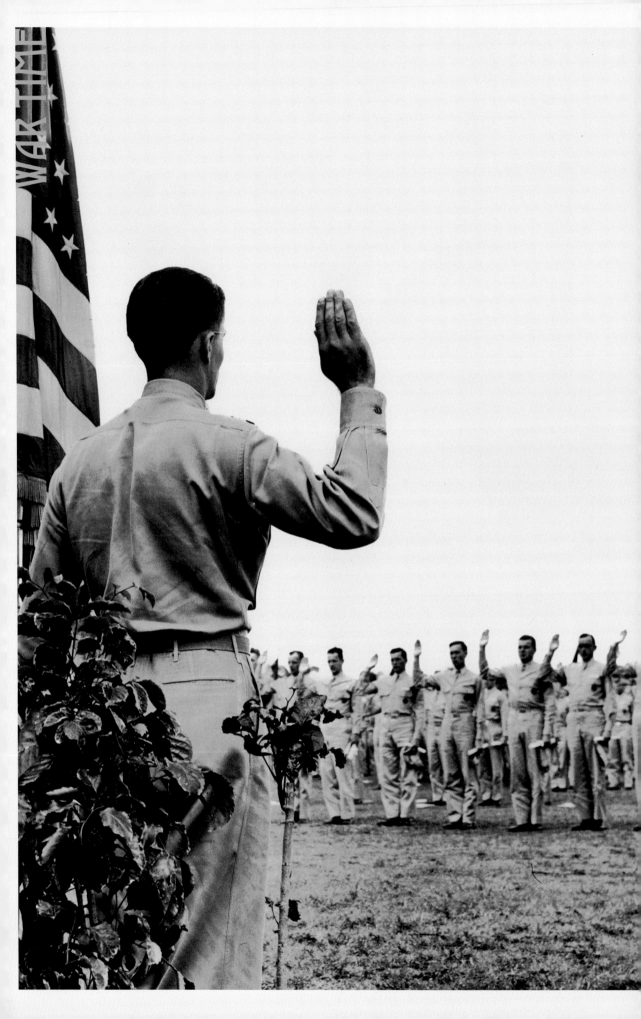

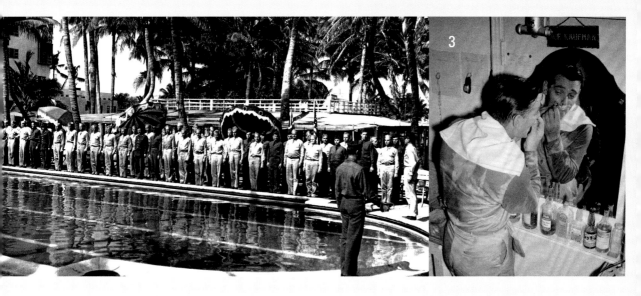

When World War II came, Miami Beach was full of Unites States Army Air Force troops in training. There were 188 hotels, 109 apartment houses, and eighteen private homes requisitioned for officers and enlisted men in training, and the Nautilus Hotel became a hospital. And tourists were still pouring in. Even with World War II raging, sun seekers went wherever rooms were available. And even though German U-boats were torpedoing tankers and freighters like the *Pan Massachusetts* and the Mexican *Potrero de Llano* were in full sight of sunbathers on the beach, Miami Beach never got scared. There was active nightlife in the large clubs lining the north side of Dade Boulevard, such as Ciro's and Papa Bouché's La Bohème. The Latin Quarter was packed with servicemen, wealthy vacationers, and beautiful chorus girls. Everyone got excited when Clark Gable showed up for training. There were complaints that too many people were going to Miami Beach and having too good a time. Didn't they know there was a war on? In August of 1945, the war with Japan ended and Miami Beach headed into yet another boom.

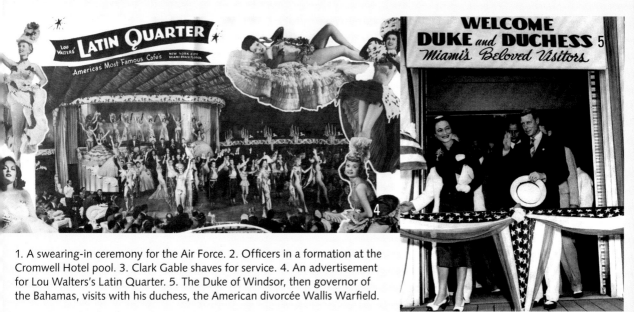

1. A swearing-in ceremony for the Air Force. 2. Officers in a formation at the Cromwell Hotel pool. 3. Clark Gable shaves for service. 4. An advertisement for Lou Walters's Latin Quarter. 5. The Duke of Windsor, then governor of the Bahamas, visits with his duchess, the American divorcée Wallis Warfield.

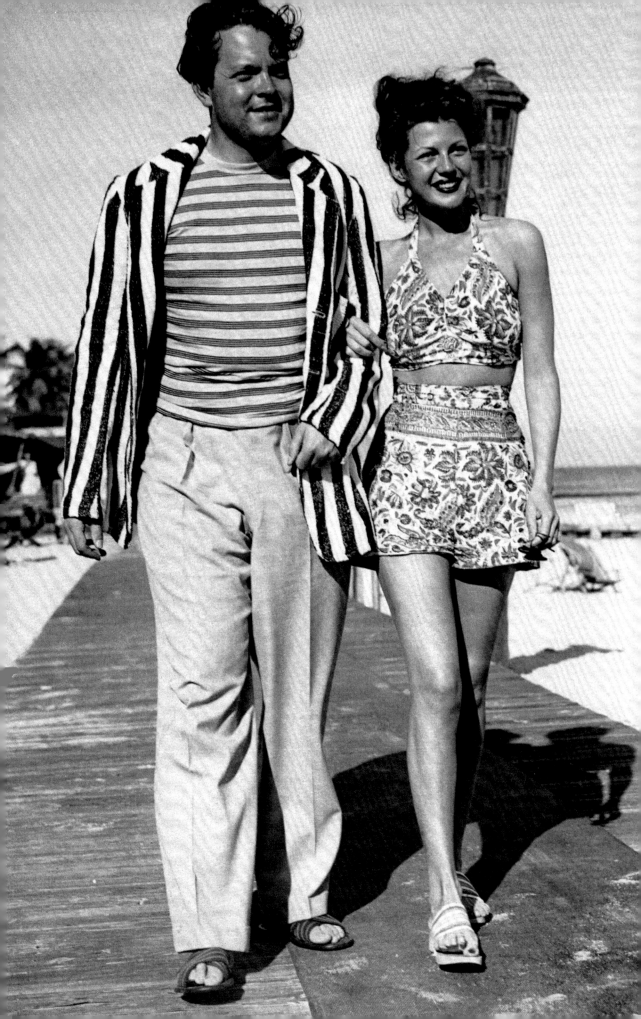

CELEBRITY CITY

In the 1950s, the architect Morris Lapidus and his followers imprinted Miami Beach with the city's half-window-dressing, half-movie-set style. And soon the decor began to attract celebrities who wanted to be the permanent gems in that setting. Arthur Godfrey, a major radio and television host, loved the beach so much that he moved his entire broadcast schedule there in 1953. Every name in American show business appeared on his show regularly, and their presence led the major hotels to add name entertainment to their nightclubs.

Frank Sinatra, Tony Bennett, and Johnny Mathis were only a few of the stars still well-known today who appeared at the Fontainebleau, the Eden Roc, the Deauville, and other hotel venues. Lou Walters, father of TV interviewer par excellence Barbara Walters, had a lavish revue at the Carillon. This was major-league. The Godfrey presence kept Miami Beach on everyone in the country's mind, and just as his career began to fade, he would be followed southward by Jackie Gleason.

For New Yorkers, particularly, it wasn't a winter if there wasn't an appearance in Miami Beach, replete with furs, jewels, new dresses—and lots of descending staircases.

Orson Welles and Rita Hayworth stroll the boardwalk, 1944.

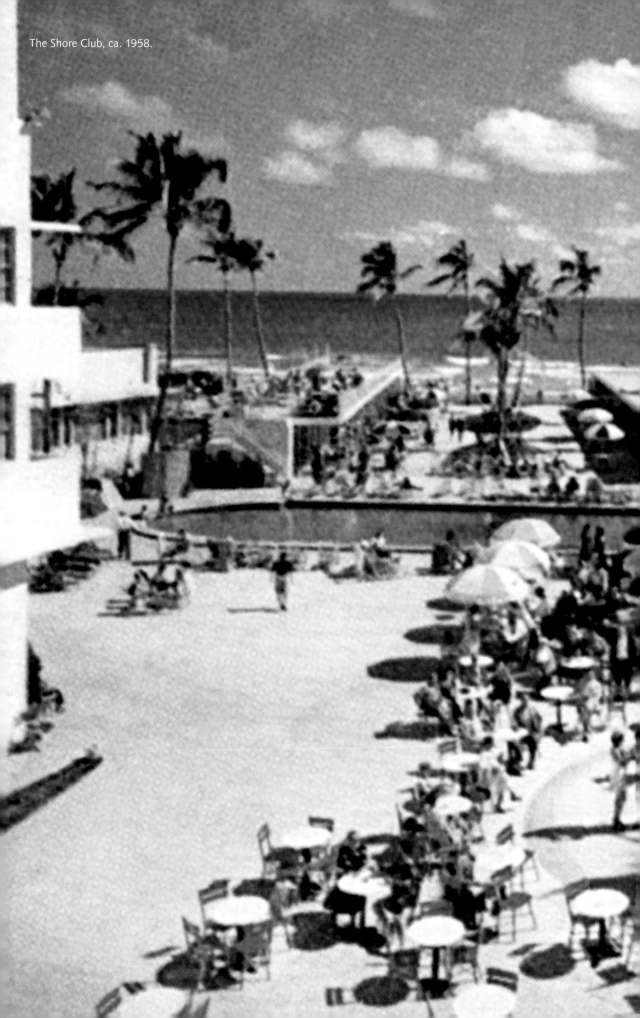

The Shore Club, ca. 1958.

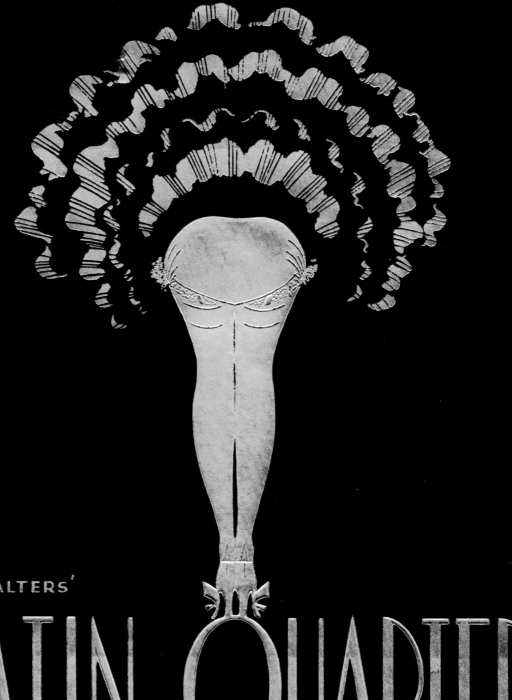

LOU WALTERS'

LATIN QUARTER

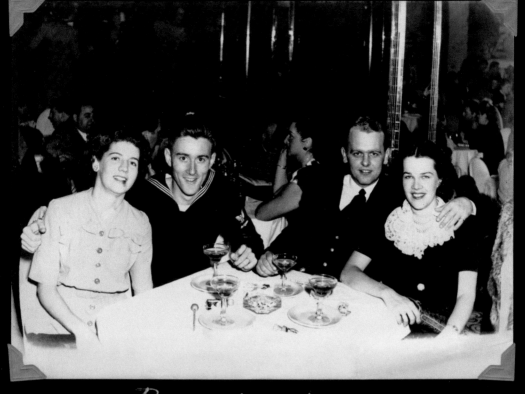

The Latin Quarter's menu cover (opposite), and guests (above).

The joke was, "Did you hear about the shark that attacked a woman swimming at the Fontainebleau? It bit off her stole."

Miami Beach epitomized glamour for the entire country. After enduring long winters and gas shortages during the war, everyone was ready to play. And heading south was where you went to do it.

Although gambling thrived unchecked in Miami Beach after the war, Washington sent the Kefauver Committee, headed by the stalwart Estes Kefauver, to investigate in 1950. It took a long time for any real cleanup, but criminal activities slowly lost their hold on Miami Beach. The trend for celebrities to play and work there was fortunate for this sunny spot. Big money had lost its newsworthiness. Now it was all about big names.

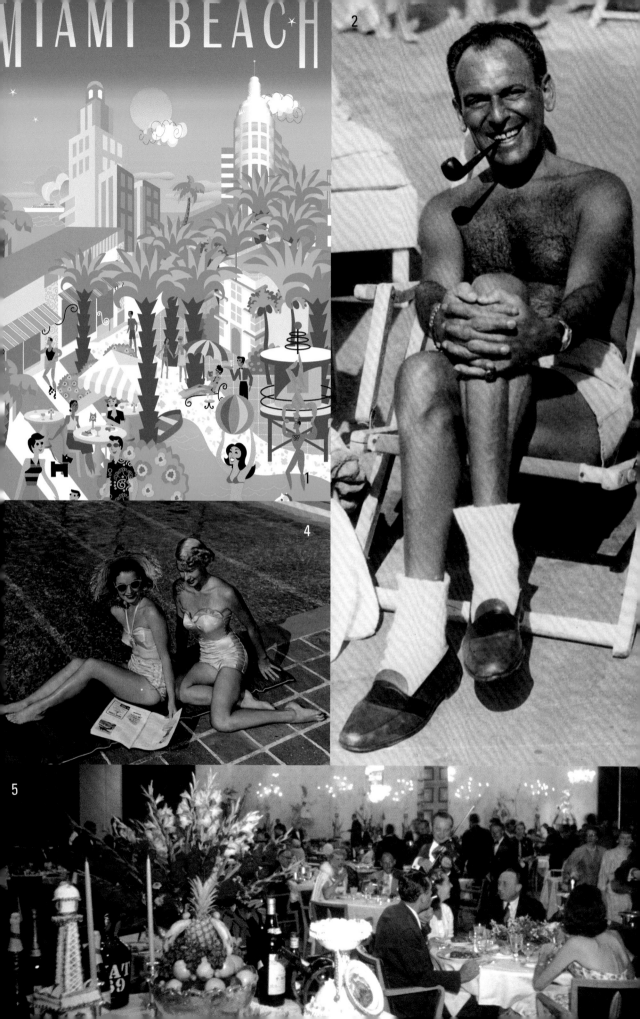

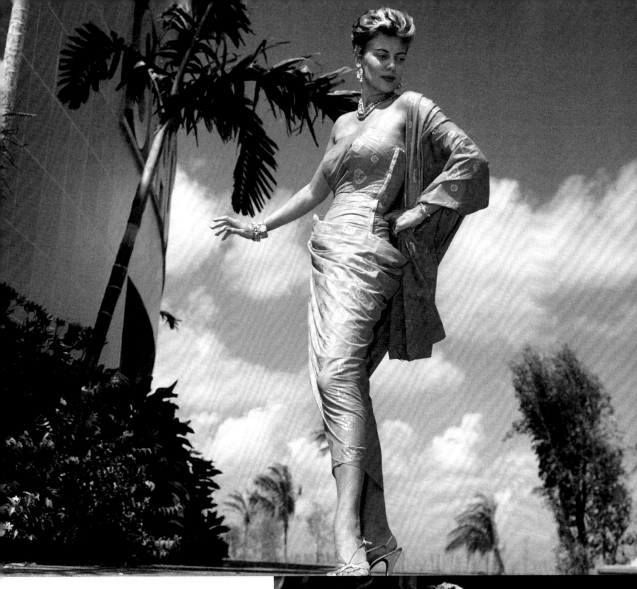

7

1. A poster for Miami Beach by Barry Zaid.
2. Playwright and movie man Moss Hart, 1946 .
3. A local fashion photo shoot, 1955.
4. Beach life in the 1950s
5. The Fountainebleau hotel dining room, 1955.
6. Movie poster for *Moon Over Miami (1941)*.
7. Radio and television host Arthur Godfrey.

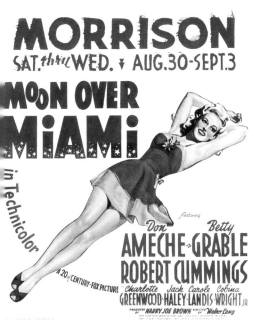

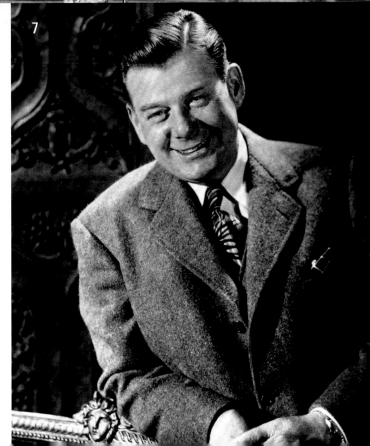

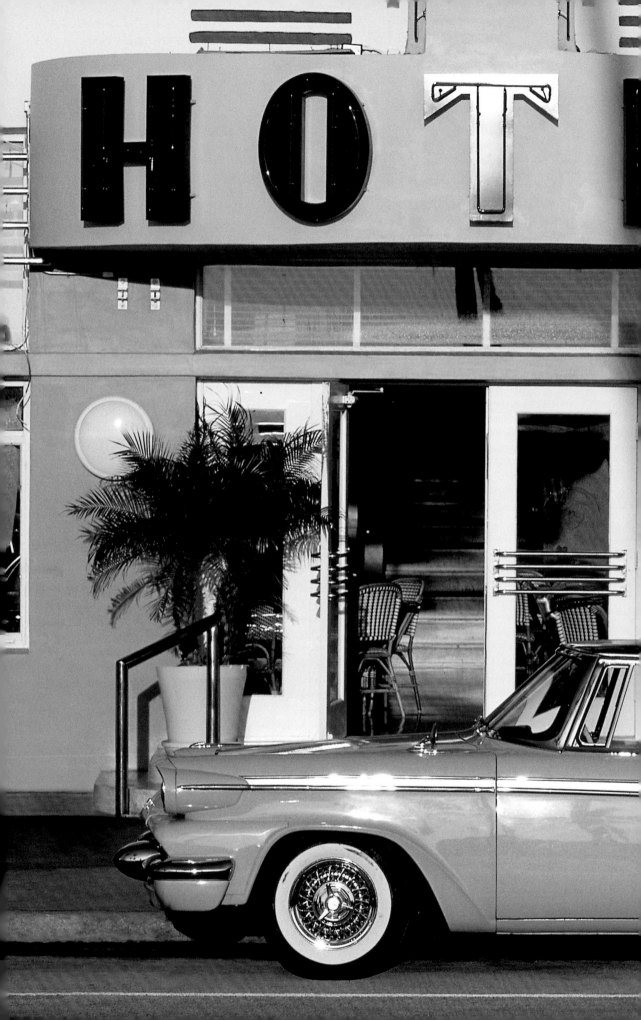

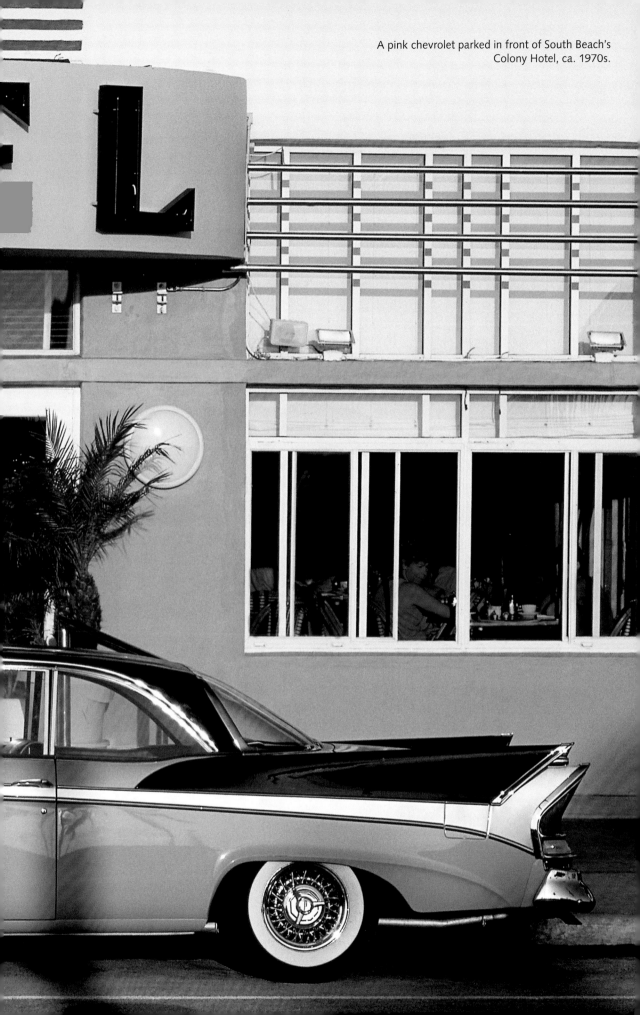

A pink chevrolet parked in front of South Beach's Colony Hotel, ca. 1970s.

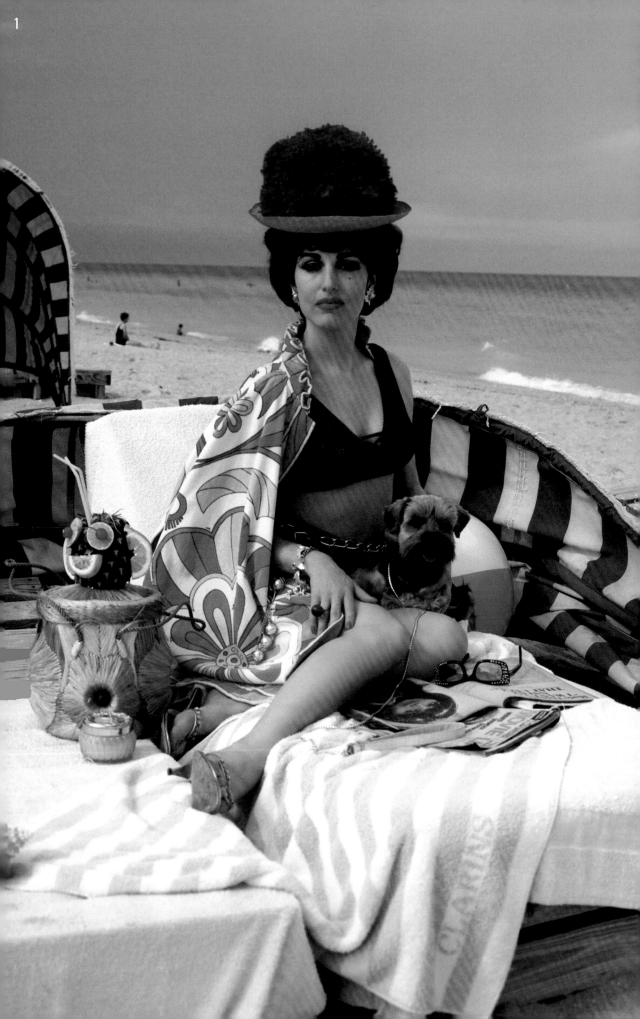

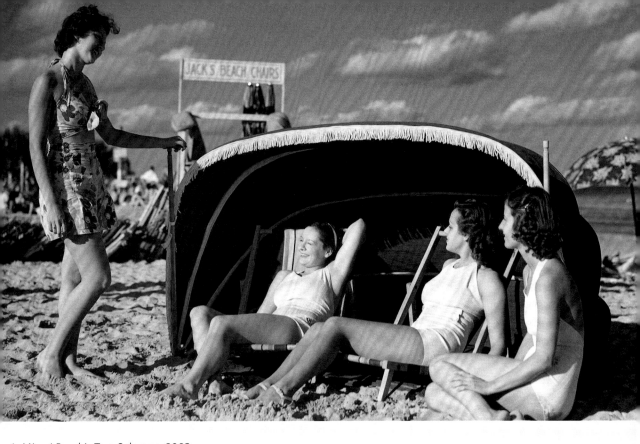

1. Miami Beach's Tara Solomon, 2003.
2. Beachgoers, ca. 1950.
3. Elizabeth Taylor (at age 17) and her fiancé William D. Pawley, 1949.
4. Errol Flynn and friend.

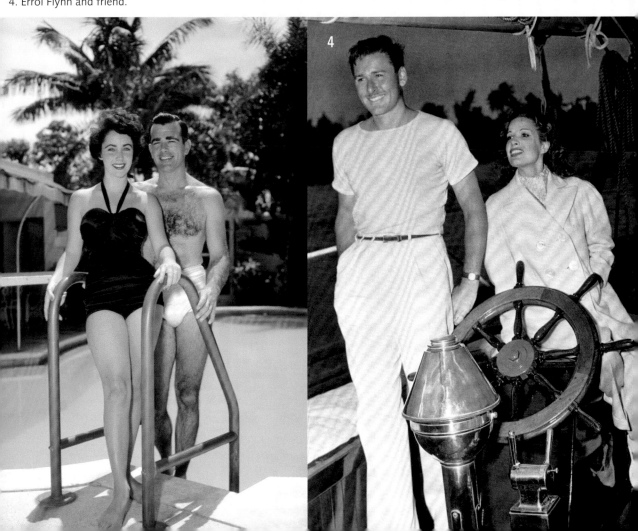

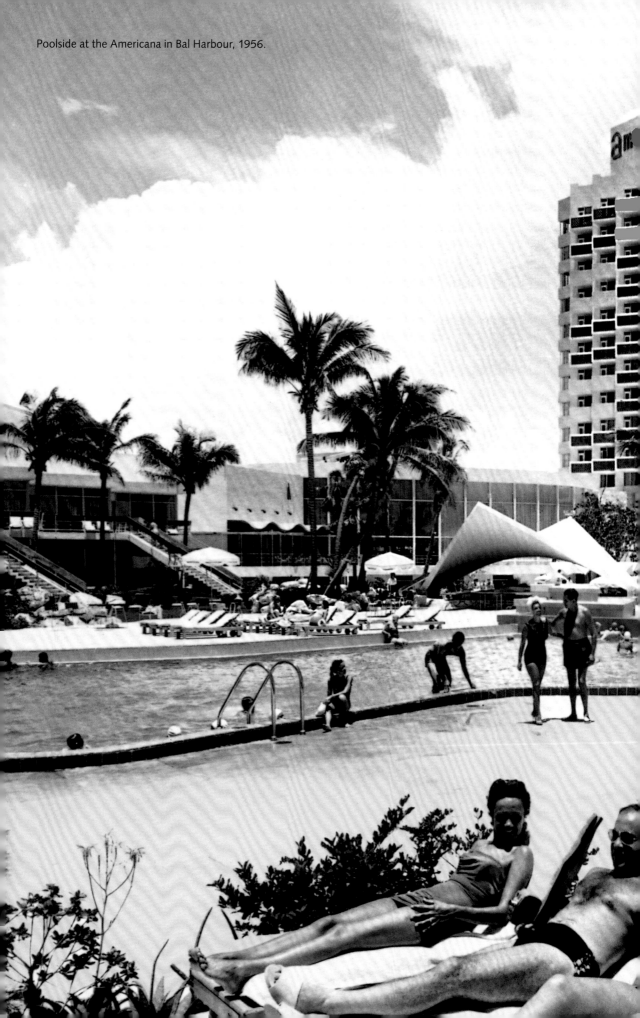

Poolside at the Americana in Bal Harbour, 1956.

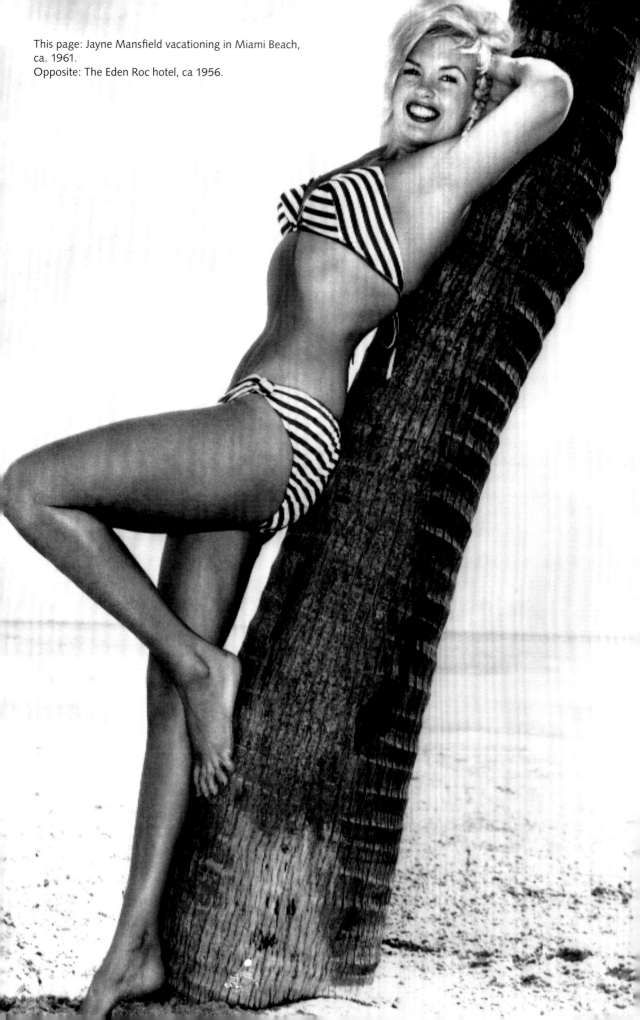

This page: Jayne Mansfield vacationing in Miami Beach, ca. 1961.
Opposite: The Eden Roc hotel, ca 1956.

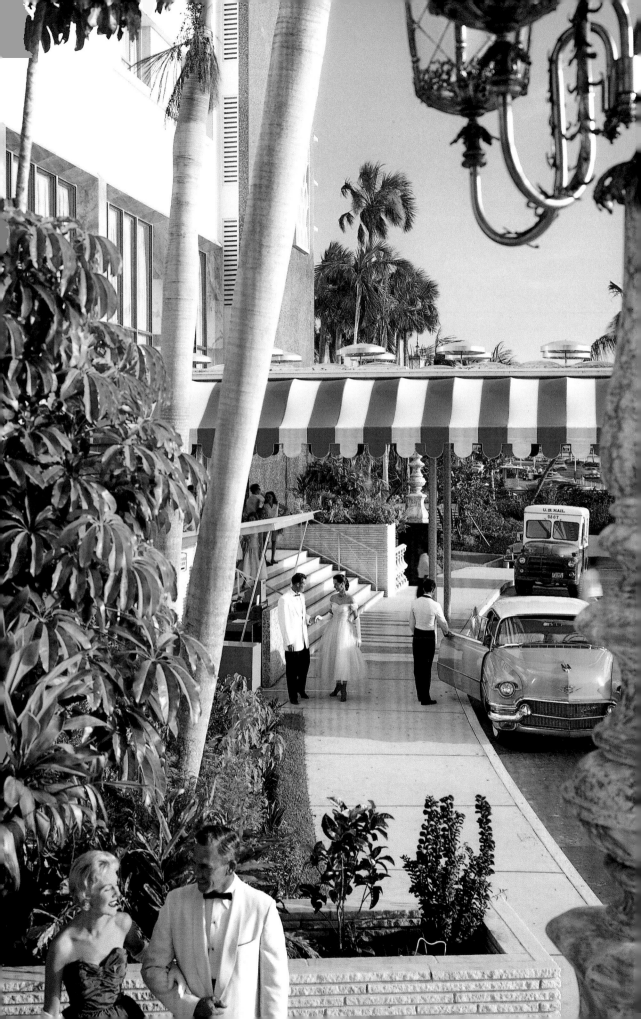

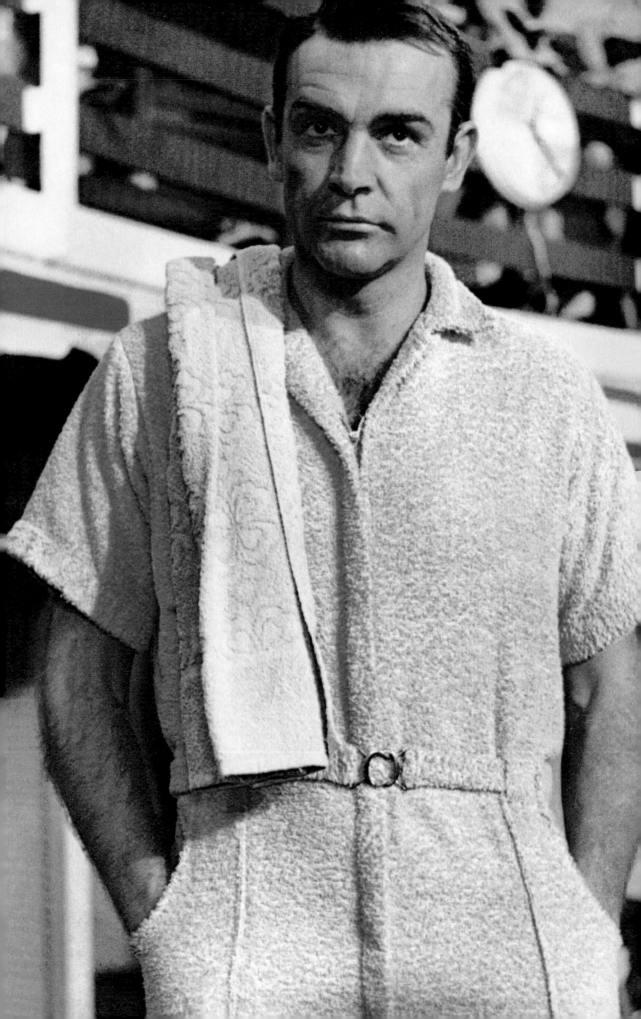

In the 1960s, all the excesses of the earlier decades in the life of Miami Beach took off. Hotels blossomed along the beachfront. Celebrities flocked to the beach in greater and greater numbers. And the television star Jackie Gleason took up residence in 1964 to be near a golf course year-round. In the wake of the success of *The Honeymooners, The Jackie Gleason Show,* his popular variety show, moved with him. "From Miami Beach, the sun and fun capital of the world, it's The Jackie Gleason Show!" its tagline roared, and suddenly the sunny, full-of-fun image of the beach became firmly implanted in the imagination of the entire country.

And when the Beatles came to Miami Beach in 1964 to appear on *The Ed Sullivan Show*—their second appearance in the country broadcast from the Deauville hotel—well, that cinched it. Now everyone wanted to respond to the advertising slogan "Come on down!" Which they did. Even the most famous boxer of his period, Cassius Clay (who later renamed himself Muhammed Ali), had a major bout in this jewel of entertainment cities. Nightlife became more frenetic. The competition among the hotels for tourists became more frantic. Mob activities and surreptitious illegal gambling became more evident.

Reality interjected itself in the Republican convention in 1968. Miami Beach had been able to distance itself from the ever-increasing tide of resistance to the Vietnam War. But now protesters were gathering. Their presence was soon overshadowed by riots in a section of Miami on the mainland called Overtown. African Americans were making their dissatisfaction known, too. The beach was beginning to lose its sunny glitter. Since it seemed such a desirable place to be, many retirees had settled on the beach. And after more than two decades had passed since Miami Beach was a sunny, sizzling destination, many of the retirees were simply becoming old people. Nightclubs were no longer of primary interest. Hotels were left to fall into disrepair. Many of those who had fled Cuba came to Miami Beach as it was one of least expensive residential areas. The bubble had burst; the party was over. Jokingly, Lenny Bruce had said, "Miami Beach is where neon went to die." Now it wasn't such a joke. Even the neon was, in fact, dying out. Crime was prevalent. Glamour had left town. It was time for a turnaround.

Sean Connery in *Goldfinger* (1964), filmed at the Fountainebleau hotel.

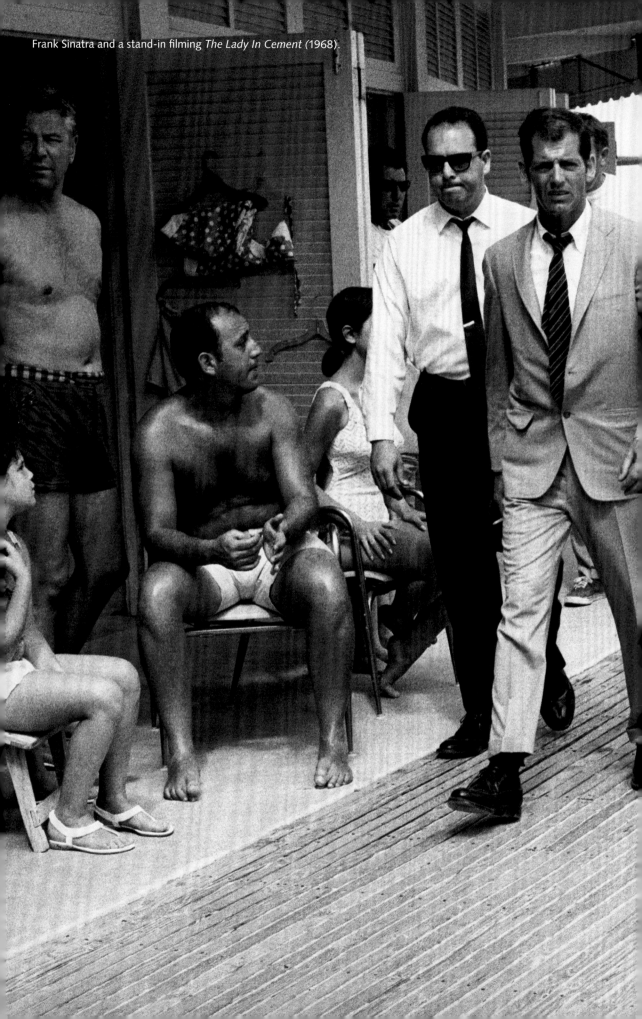

Frank Sinatra and a stand-in filming *The Lady In Cement* (1968).

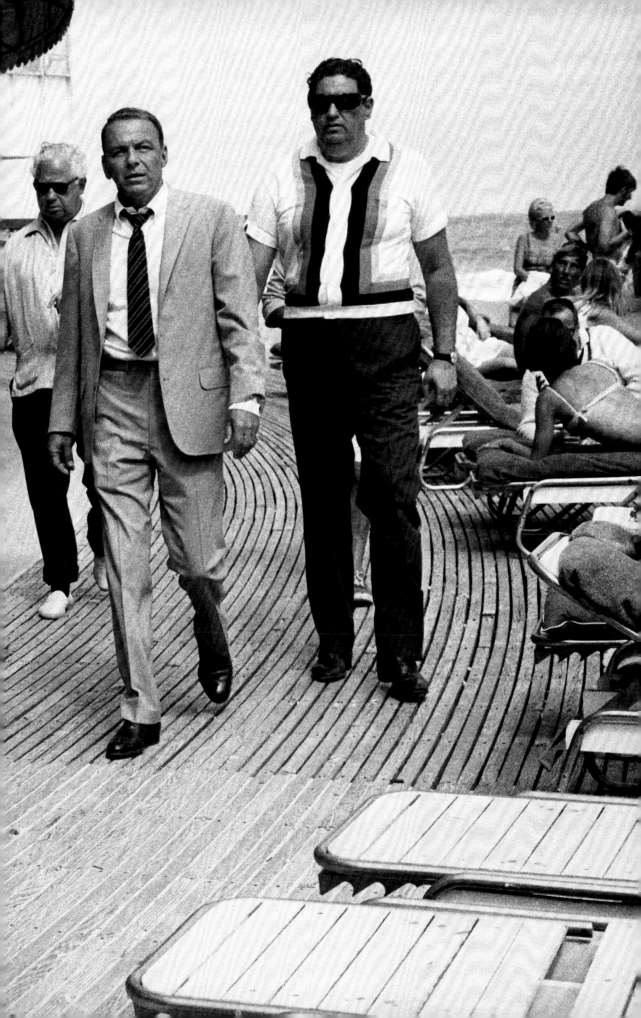

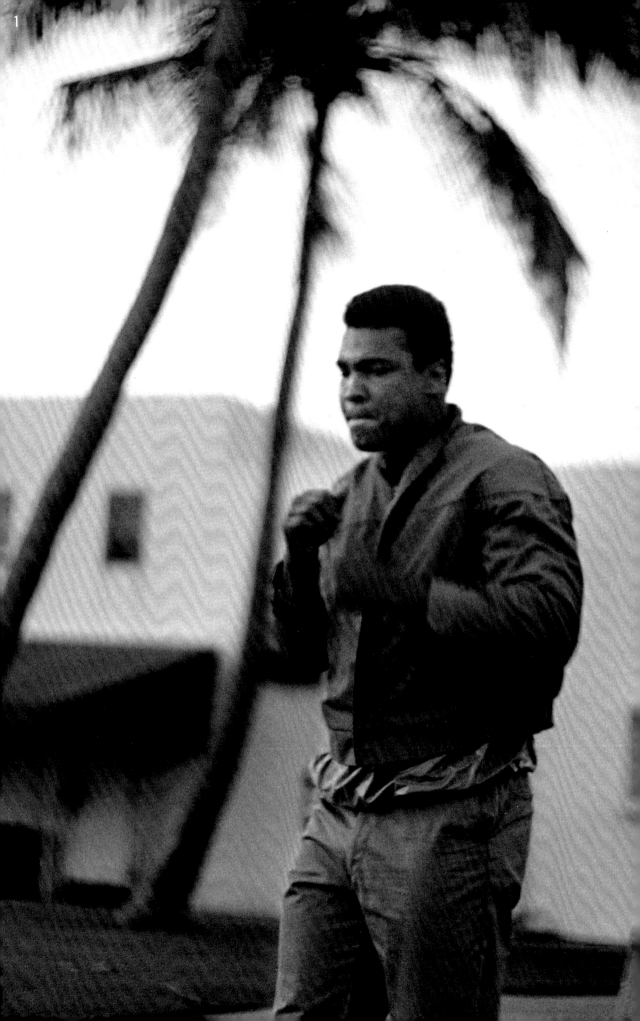

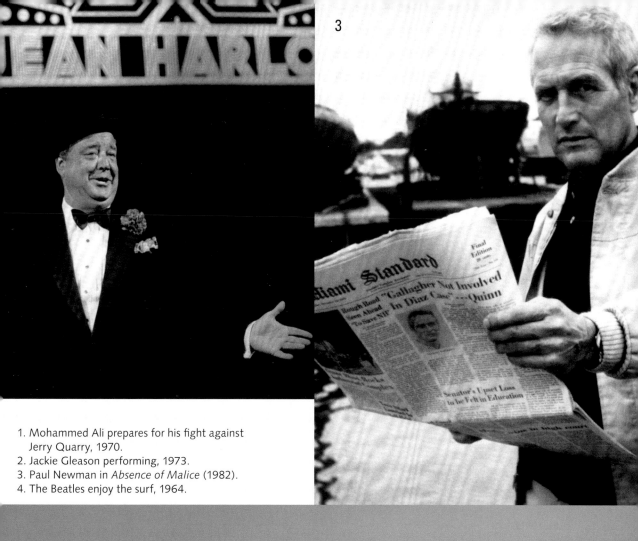

1. Mohammed Ali prepares for his fight against Jerry Quarry, 1970.
2. Jackie Gleason performing, 1973.
3. Paul Newman in *Absence of Malice* (1982).
4. The Beatles enjoy the surf, 1964.

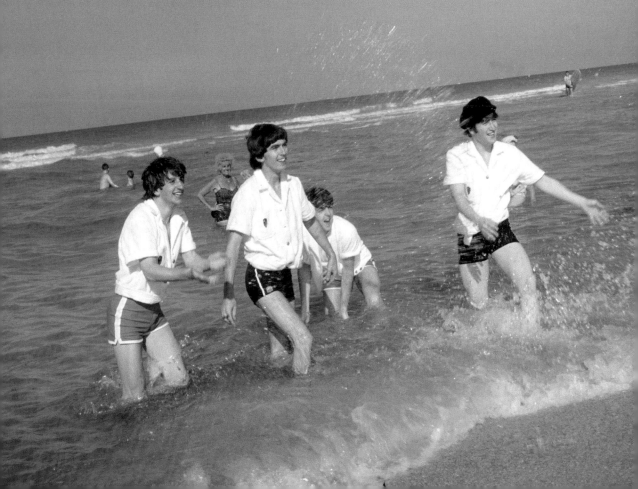

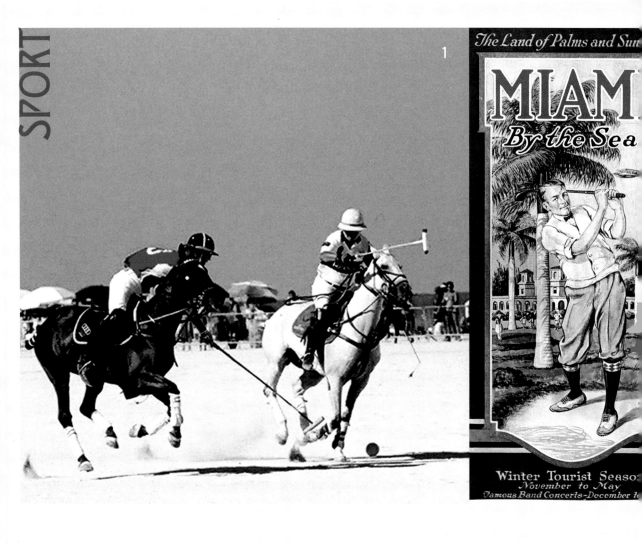

The Land of Palms and Sun

MIAM

By the Sea

Winter Tourist Season
November to May
Famous Band Concerts–December 1e

1–6. A sampling of popular sports in Miami Beach.

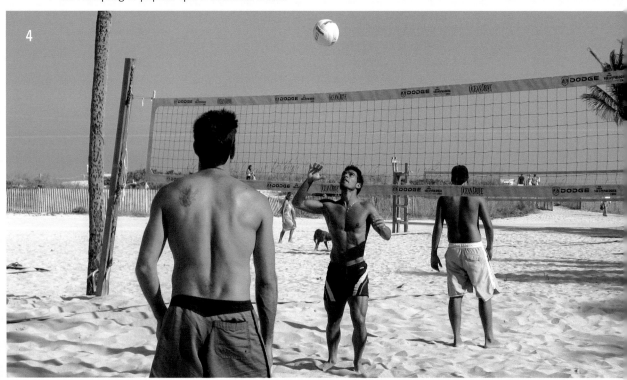

4

It's a sporting life in Miami Beach. But somewhat differently than in most beach and resort communities. From the very earliest days, when Miami citizens came across the bay and trekked through the swamps to swim, leaping in the ocean was the number one sport. So important was swimming that pools existed when just a handful of residents actually lived on this sandbar offshore from the city of Miami.

Swimming remains popular, but the beach is also covered with volleyball games, and even polo. The sidewalks are equally well-supplied with barely covered bicyclists, skateboarders, and rollerbladers. Perhaps the most contemporary phenomenon are the many gyms, catering to all the body-conscious beauties, male and female, in Miami Beach.

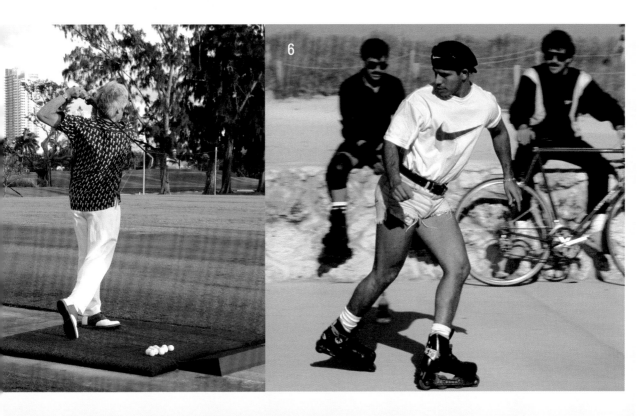

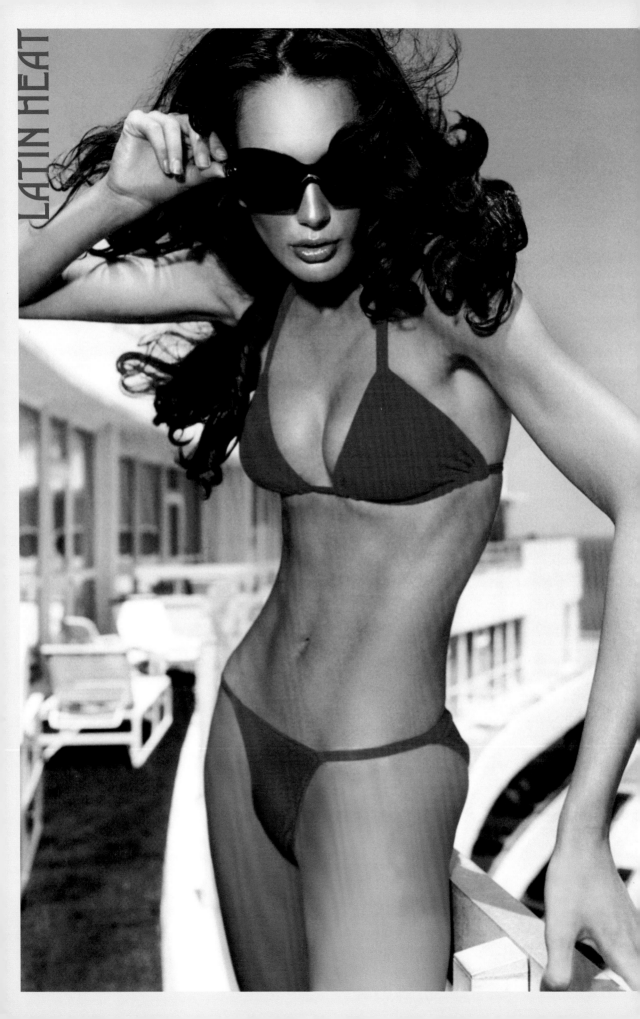

Española way, Miami Beach's little Spanish enclave north of 14th Street, between Washington and Pennsylvania avenues, was conceived by N. B. T. Roney as a bohemian colony for artists in the 1920s. He hoped they would gather there and add local color. They did not, but Española Way was indeed a harbinger for the strong Latin American influence in Miami Beach. Although Carl Fisher had a taste for Venetian-style architecture, he was also partial to Spanish Baroque. This is a style that permeates Española Way, with the stucco and tile exteriors of one-and two-story buildings that line its three blocks. The rich, rolling curves and dripping stone shapes are particularly suited to the tropics, with the vivid colors, strong sunlight, and rich, flowering greenery on every hand.

1–4. Colorful scenes on Española way.

1

3

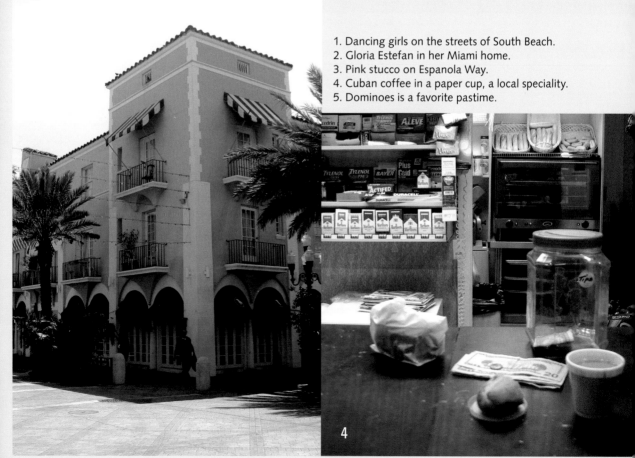

4

1. Dancing girls on the streets of South Beach.
2. Gloria Estefan in her Miami home.
3. Pink stucco on Espanola Way.
4. Cuban coffee in a paper cup, a local speciality.
5. Dominoes is a favorite pastime.

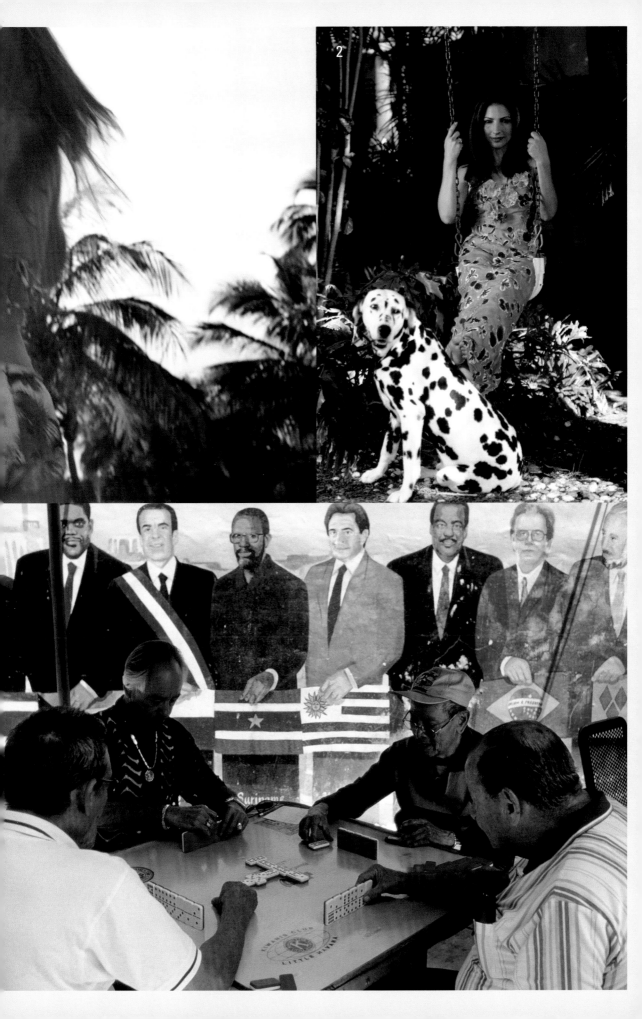

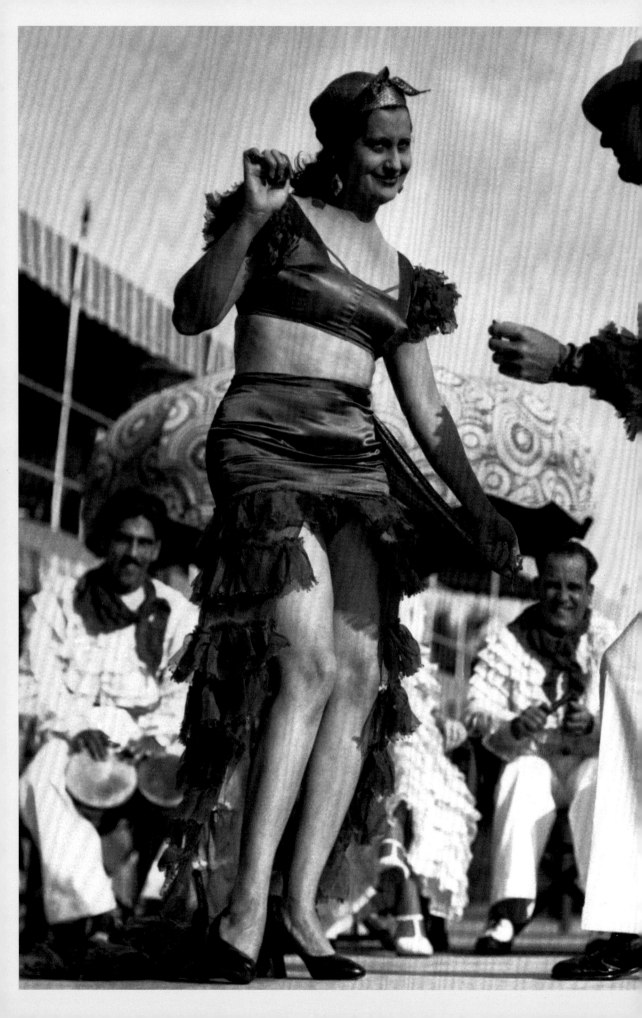

The Latin American influence can be found in many cafés and small food shops in and around Miami Beach. And so can its intense coffee, served in tiny paper cups at food counters everywhere. Two little cups of that rich potion will get anyone up and going for the day.

Along the stretches of Miami Beach are many Cuban restaurants, Argentinean restaurants, and food redolent of all the Latin American countries. The clothes worn are vivid with the colors favored in this world where the light is bright, day or night. And the music in the air has the sensuality, the rhythm, and the heat of these cultures that stretch south from Florida.

Louis and Margarite Arango, dance instructors at the Roney Plaza, give a demonstration of the authentic Rhumba while the El Dulce Orchestra plays their accompaniment, 1933.

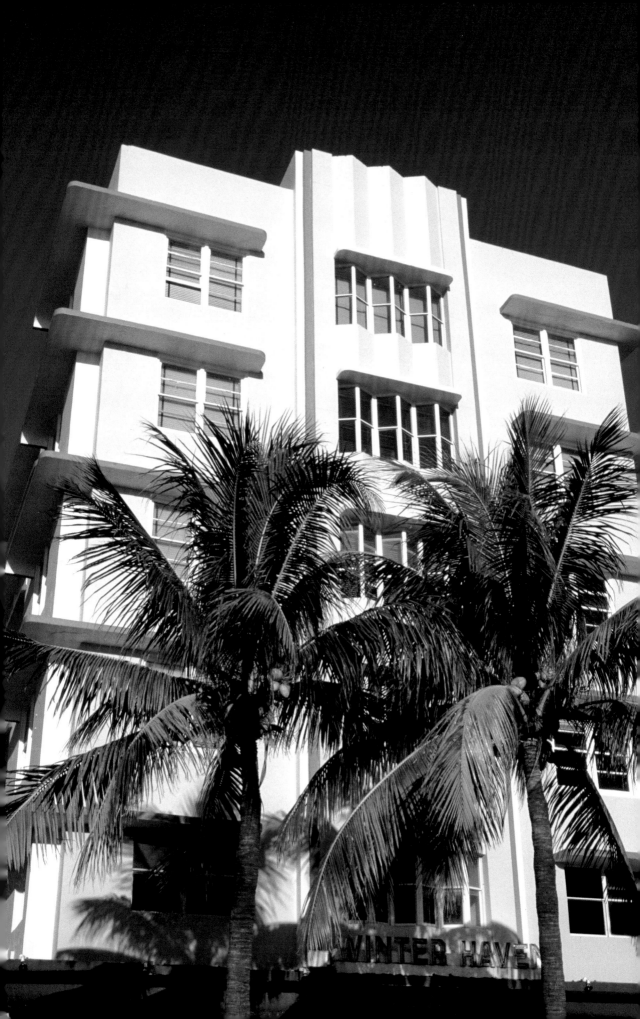

ART DECO TO
MIAMI MODERN

Following the war, developments in air transportation evolved into a popular new way of traveling. Now hundreds of people from all over the country could come to Miami quickly and affordably. And they did. Again, the millionaires who once played in Miami Beach had a role in the making of the city. The stretch of beach where their homes stood would become a strip of vast hotels to accommodate the new airborne crowds. First to go was the Firestone mansion just above 41st Street; the Fontainebleau Hotel arose in its stead. The hotel stole its name from the Château of Fontainebleu in France. Evidently, the new owners thought that *eau,* for "water," was easier to pronounce than *bleu,* for "blue." Perhaps they just made a mistake.

The hotel was anything but French. In the hands of the architect Morris Lapidus, it was a curving fortress of many rooms, glitzed up with a sweeping staircase to nowhere that women could descend in their cinched-waist, full-skirted New Look gowns, topped off with glamorous fur stoles. French statuary and ornaments and a formal garden gave the hotel whatever Gallic class it had. Lapidus understood the postwar mood. Vacations were not to relax quietly. Vacations were to rent jewels, overspend on limousines, and,

The Beacon Hotel on South Beach's Ocean Drive.

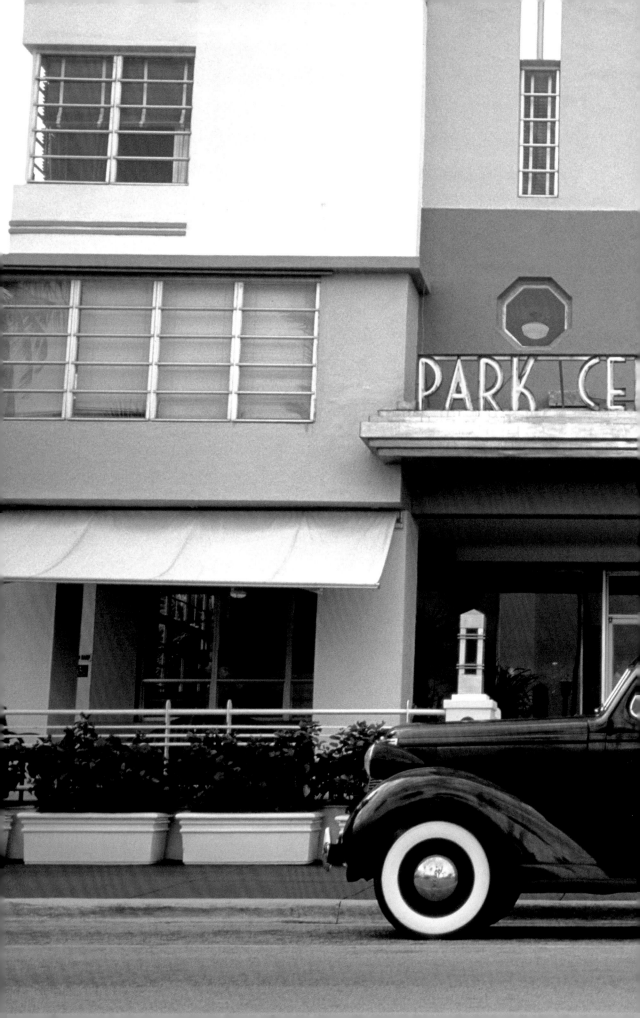

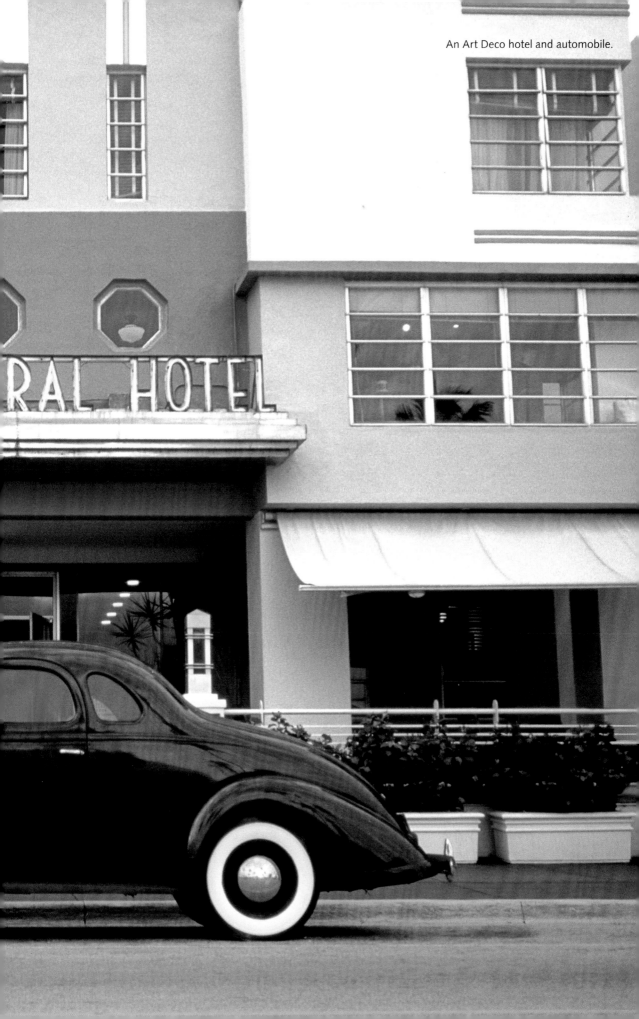

An Art Deco hotel and automobile.

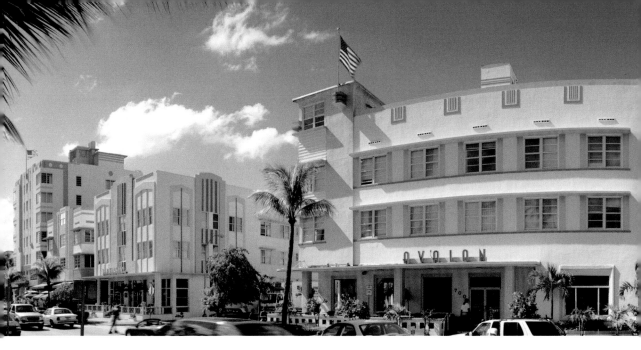

"If you've got it, flaunt it!" His hotels, filled with purposeless leaning pillars, pierced ceilings, and amoeba-shaped decorations on the wall, looked entirely different and new. Architects hated the meaninglessness of it all. The public loved it.

But as the 1960s became the 1970s, Miami Beach began to show its age. Transportation, which once shuttled visitors to the South en masse, now drove the tourist tide away. Jetting off to the Riviera was a newfound temptation, airplanes grew larger and larger, and travel prices became lower and lower. In the early 1960s, a trip to Europe became readily available. Americans could hop on a plane and travel farther and farther away—rapidly and cheaply. *If It's Thursday It Must Be Belgium,* the 1969 film, said it all. You wanted to come home and brag about Paris, not Miami Beach.

The town became a kind of battleground. In both 1968 and 1972, there were political conventions at which violence erupted. Miami Beach began to have an edge of danger to its name. This perilous flavor was intensified with the flood of Cubans who were allowed to enter the United States by Fidel Castro in 1980. He also emptied his prisons, and many of the emigrés who came over in the Mariel boatlift came to be known as Marielitos. Most settled in Miami Beach, and without the support of families or language, poverty and crime reappeared. There was a lot of disagreement as to what was to be done to overhaul Miami Beach to restore its image and prosperity.

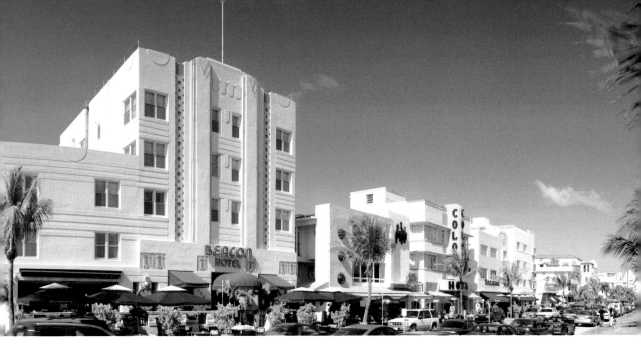

Art Deco architecture lines Ocean Drive.

Some enthusiasts wanted to completely raze the southern part of the beach and create a whole new environment of modern buildings and Venetian-style waterways. Others opposed this idea. No one really knew what to do about a community that now consisted largely of low-income retirees and no-income immigrants. Then Barbara Capitman came on the horizon.

Capitman was a widow, no longer young, who saw the Art Deco architecture of Miami Beach as a treasure trove not to be destroyed. Together with the designer Leonard Horowitz, she galvanized the community, and by 1978 there were one thousand members in her Miami Design Preservation League. Efforts were made to stop the destruction of some landmark buildings. Most failed. The consequent hullabaloo brought Miami Beach to the country's attention again. Horowitz conceived witty and colorful ways to paint the old buildings so they were eminently photographable. Books followed; artists took up residence. And by the early 1980s, people began to realize that these great-looking buildings were adjacent to a fantastic beach, completely rebuilt by the U.S. government—and prices were low, low, low.

Hoteliers began to appear from New York. Art Deco was an unfamiliar term to locals and there was resistance to the deification of hotels and apartment buildings that seemed to be just old and crumbling as far as many people were concerned. But by 1986 it was chic to winter, weekend, or even live in Miami Beach. It was the only town in the whole country where

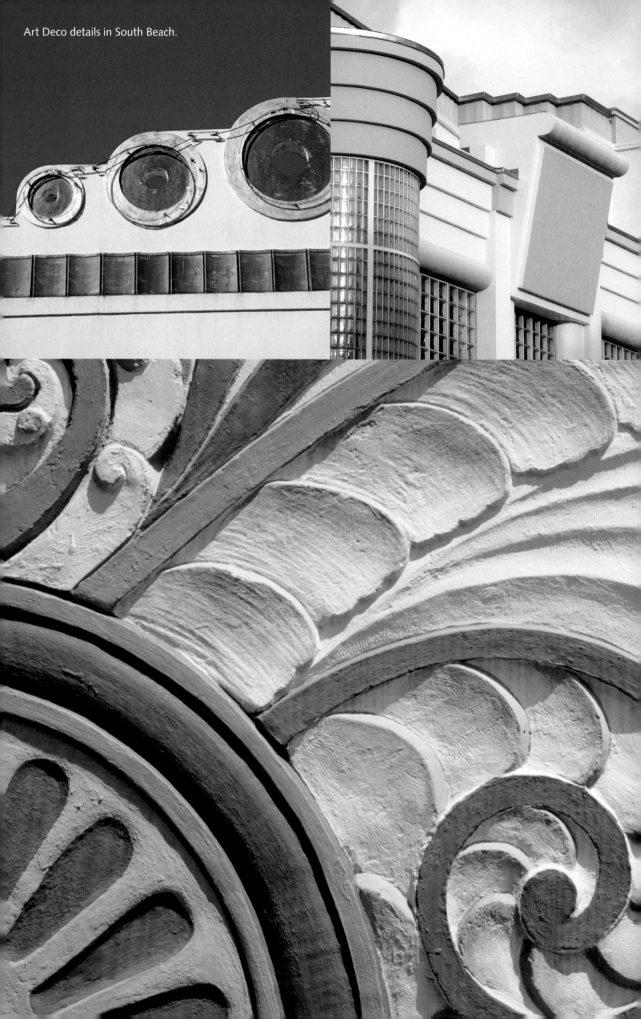

Art Deco details in South Beach.

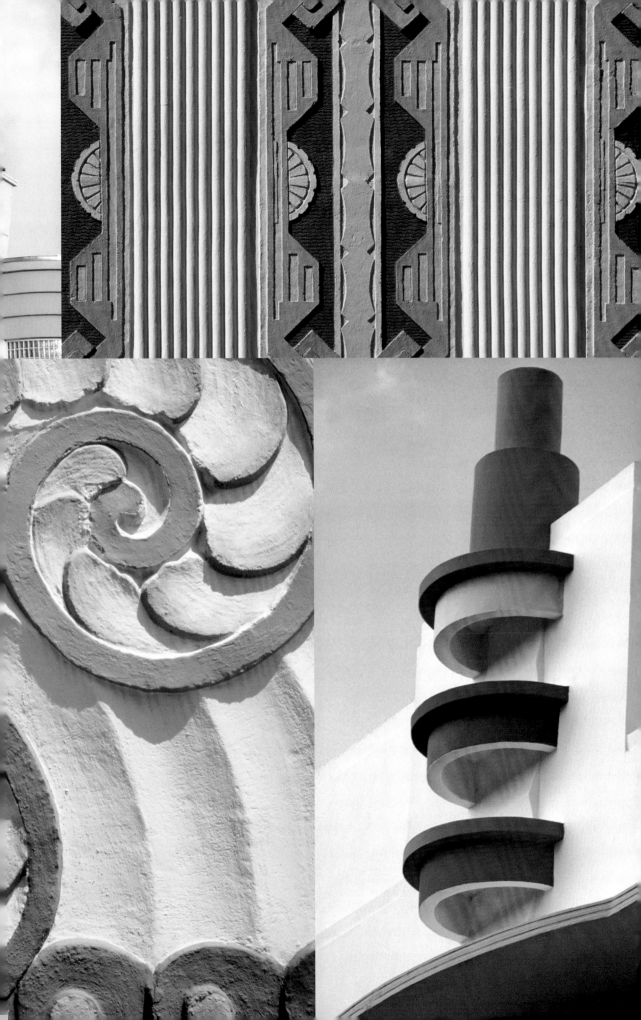

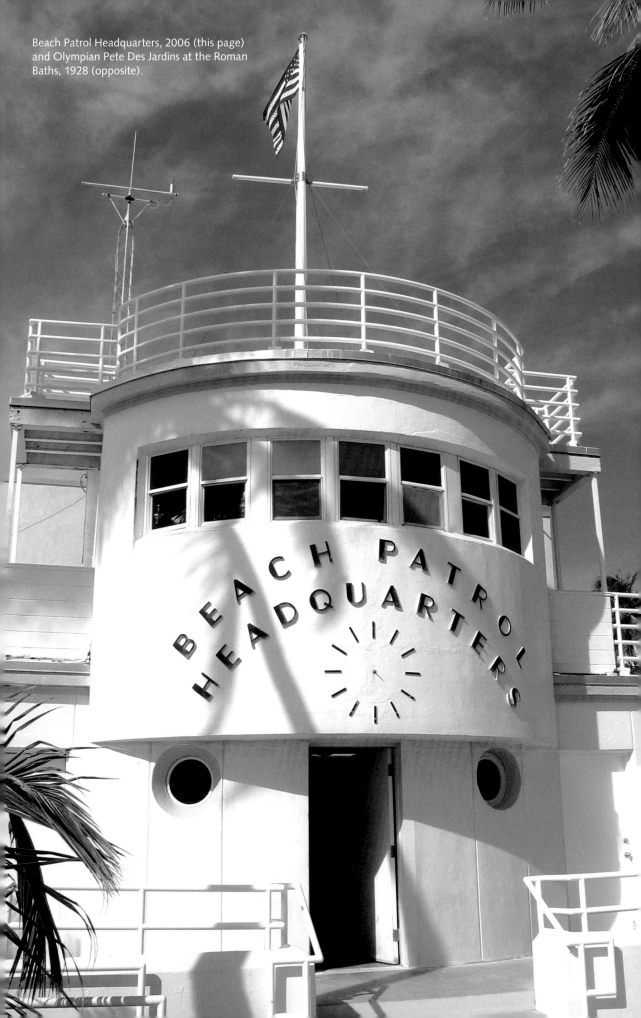

Beach Patrol Headquarters, 2006 (this page) and Olympian Pete Des Jardins at the Roman Baths, 1928 (opposite).

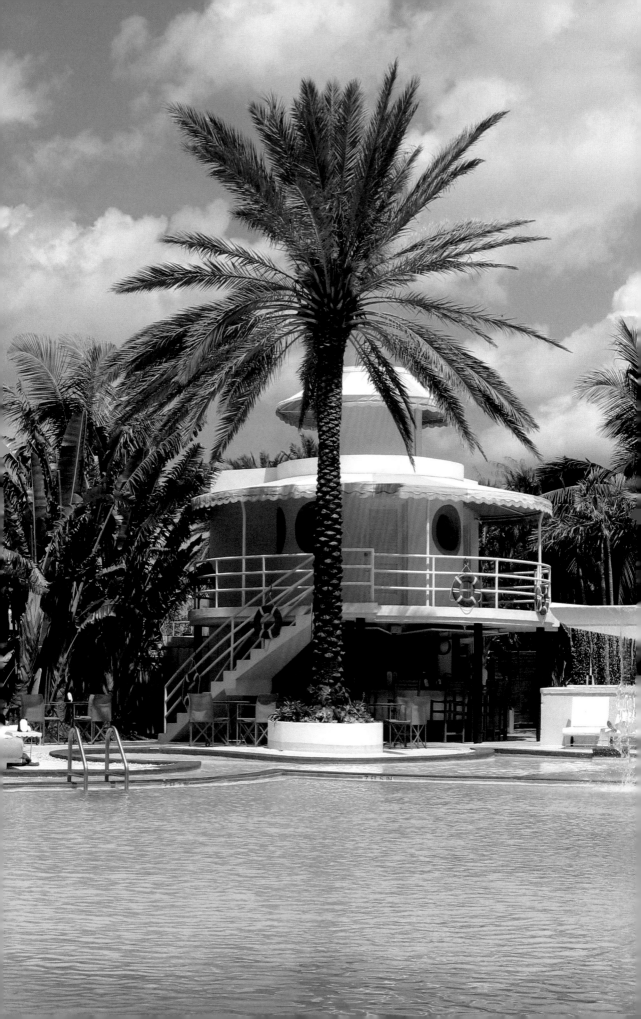

groundbreaking ideas for the decoration of bars and hotels were taking shape. The fusion of the numerous mixed communities created a welcoming atmosphere for people from all over the world. Modeling agencies opened, the beautiful people began flooding in. A new kind of dream had been created. By the time Barbara Capitman died in 1990 her vision had been completely justified. Miami Beach was back, bigger and better than ever.

With the renovation of the Hotel Delano in 1995, another era of glamour swept into Miami Beach. Built in 1947 and named after the president Franklin Delano Roosevelt (in the patriotric spirit of the postwar era), the reopening of this Modernist-style gem was the brainchild of hotelier Ian Schrager, of Studio 54 fame, who is now renowned for his renovations of the Morgans, Paramount, and Royalton hotels in New York. From teaspoons to telephones, every inch of the hotel bears a designer emblem. The French architect Phillipe Starck was employed, and the Delano was re-dressed in great blowing white curtains, towering mirrors, quirky chairs, a restaurant called the Blue Door (partially owned by Madonna), and a dramatic staircase descending to the pool area. The pool was built in the newly popular infinity style, and female guests were encouraged to divest themselves of their hindering upper garments. Euro-chic had arrived.

Next came the neighboring Raleigh Hotel. Already the site of what is considered the most beautiful pool in Miami Beach, best known for having welcomed the body of swimming-film star Esther Williams at some time in the past, the lobby and dining room were sleeked up by another legendary hotel wizard, Andre Balazs. Soon tourists flocked to both.

The Shelborne, The Standard, the National, The Tides, The Shore Club, The Setai, and many others followed suit, culminating with Casa Tua, an elegant hostelry in what was once the home of the rabbi of a large synagogue. It is so exclusive that locals are heard to say, "You can't even go there."

Once the renovation of Art Deco hotels was underway, there was a newfound interest in building hotels and apartment houses that were not necessarily in the Art Deco tradition. Among the first was Il Villagio, the only building to get permission from the city of Miami Beach to build directly upon an empty stretch of beach at 15th Street and Ocean Drive.

The pool at The Raleigh Hotel.

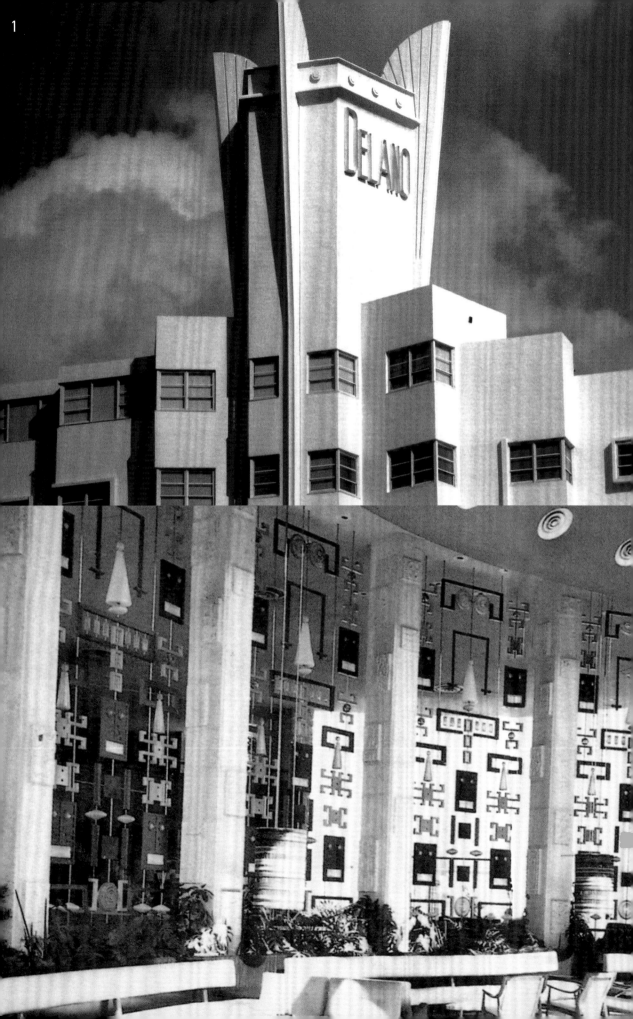

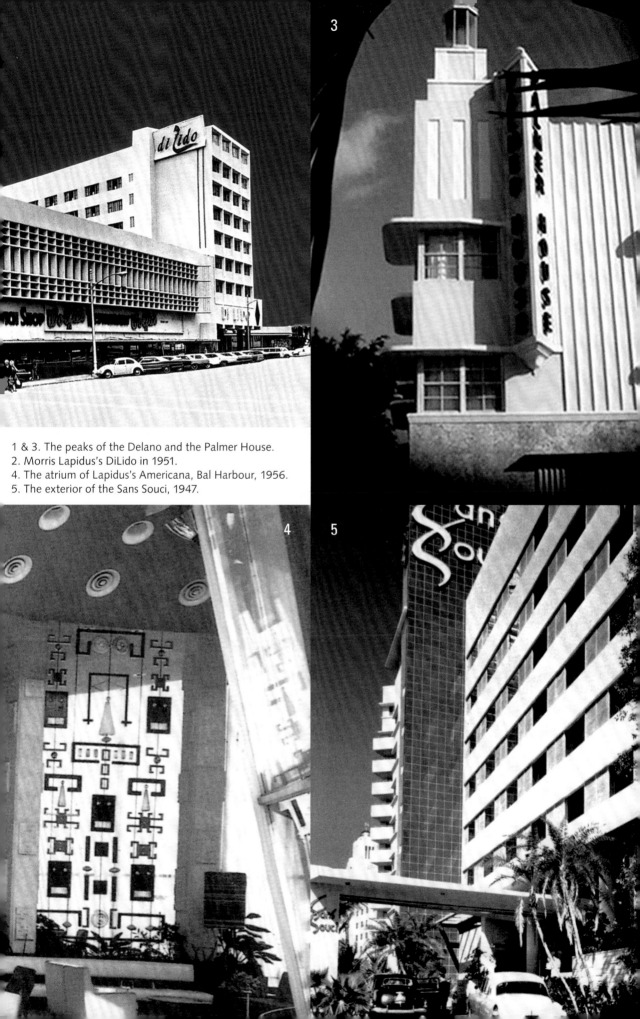

1 & 3. The peaks of the Delano and the Palmer House.
2. Morris Lapidus's DiLido in 1951.
4. The atrium of Lapidus's Americana, Bal Harbour, 1956.
5. The exterior of the Sans Souci, 1947.

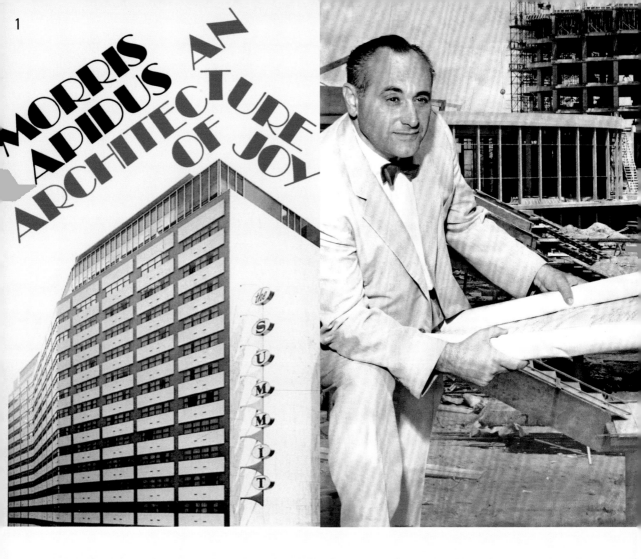

1. The jacket cover of Morris Lapidus's book, *An Architecture of Joy*.
2. Lapidus on the construction site of the Americana, Bal Harbour, 1956.
3. The Fountainebleau hotel, ca. 1955.
4. The interior of Lapidus's office, 1945.

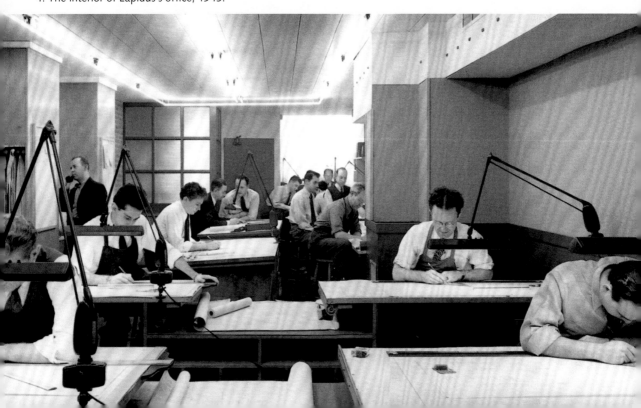

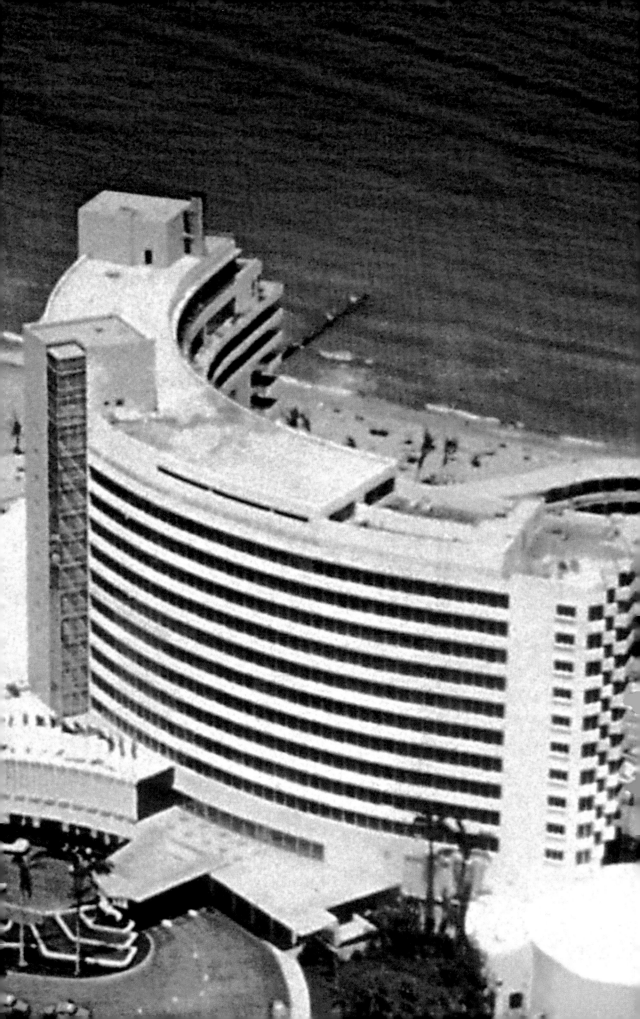

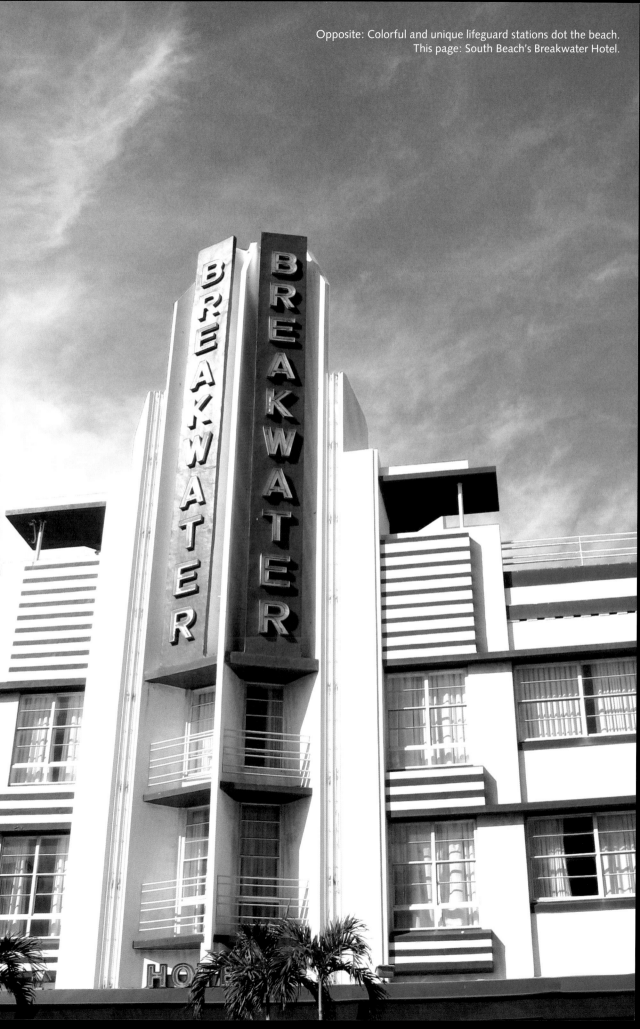

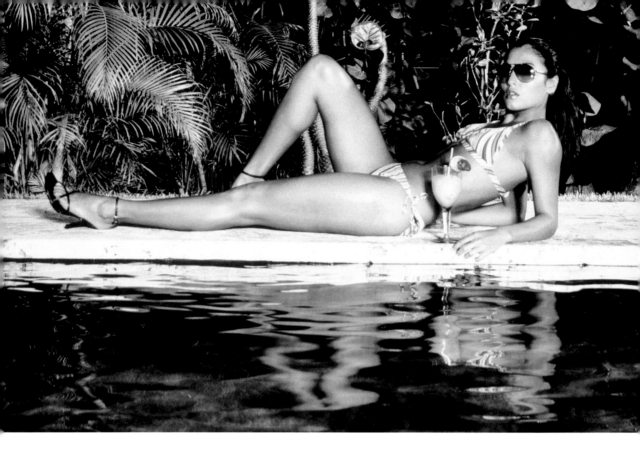

Perhaps the fact that this was once the site of the famed Villa Venice nightclub allowed Il Villagio to reclaim it. Farther up the beach, enormous apartment buildings like the Green Diamond and the Blue Diamond, the Fountainebleau II, the Akoya and many more, were built. At the very tip of Miami Beach a group of buildings called South Pointe Towers were begun, not yet completed at this writing. They rise high above the cruise ships that pass in and out through the entrance to Miami harbor at their feet.

Nearby are the very latest projects, the Continuum and the Icon. These buildings add swank to Miami Beach. Both are partially inspired by Art Deco and partially inspired by Phillipe Starck, but on an almost superhuman scale. The enormous draperies in the Icon have to be seen to be believed.

Real estate experts say that Miami Beach has issued all the building permits possible for the foreseeable future. The view we now have of the hotels and resident buildings in Miami Beach may well be the view for years to come. Now only the prices will go up.

The Raleigh pool (opposite) and a sunbather (above).

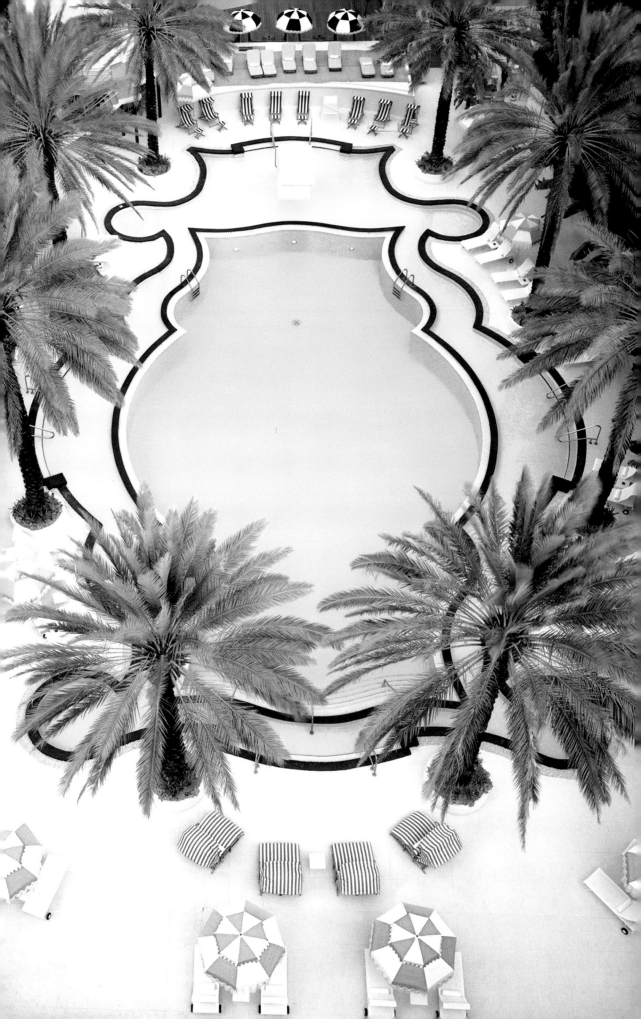

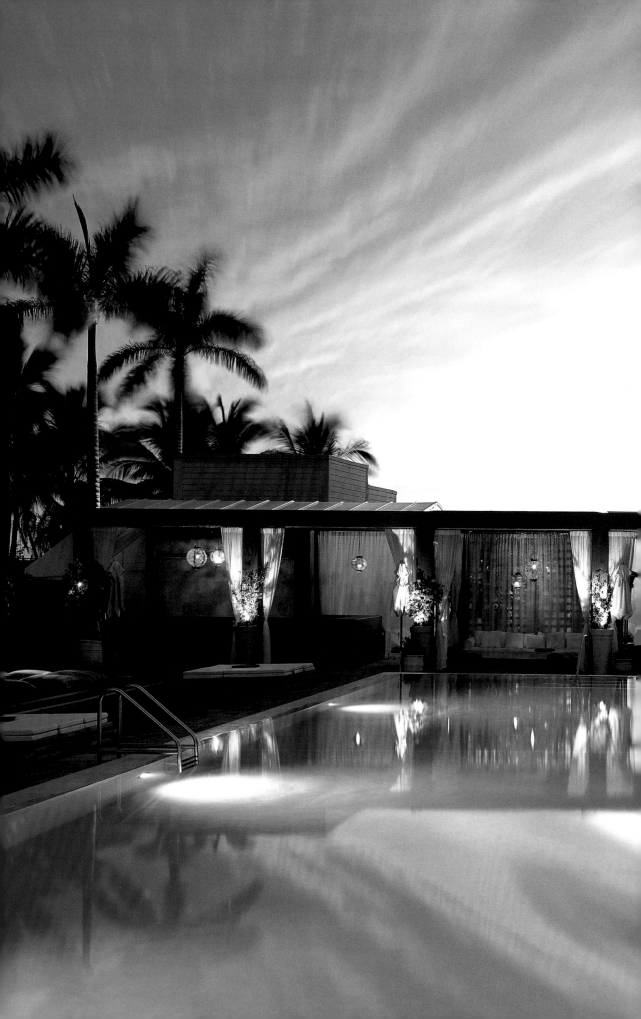

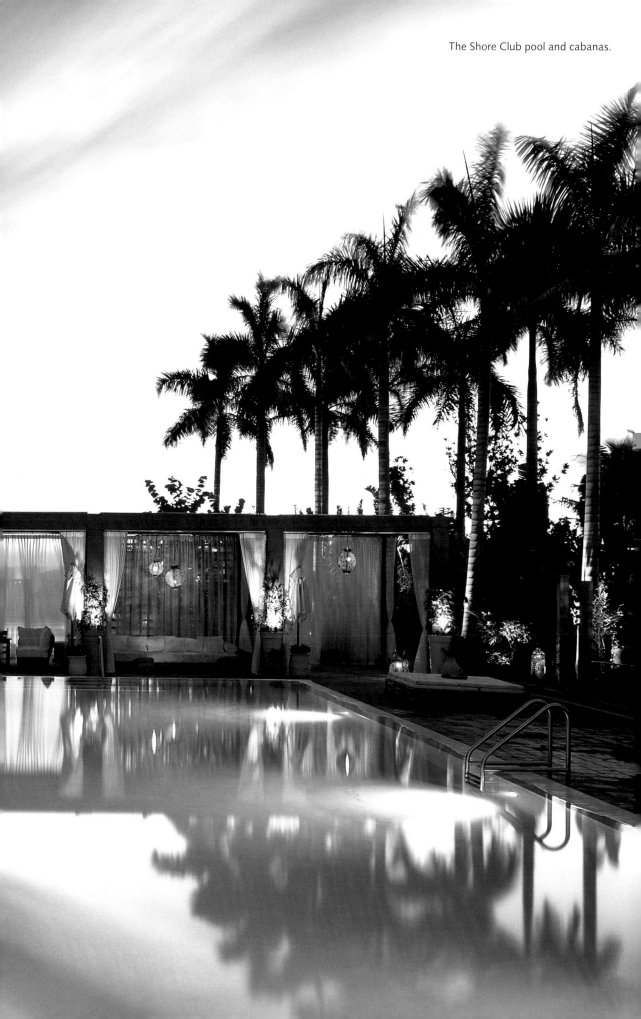

The Shore Club pool and cabanas.

The first sign of a renaissance of culture in Miami Beach was the conversion of deserted storefronts on Lincoln Road into artists' studios in the early 1980s, most notably the ArtCenter/South Florida. Bohemia reigned, and small coffee shops and friendly bars opened nearby. It was a turning point for art, as well as for Lincoln Road. In 1983, in came celebrated artists Christo and Jeanne-Claude, who surrounded eleven islands in Biscayne Bay with pink woven polypropylene fabric, between the cities of Miami and Miami Beach. The world took notice.

The Great Leap Forward was the arrival of Art Basel in Miami Beach in 2002. Although there were already large art fairs on the beach, Art Basel legitimized what the rest of the country considered a feckless seaside resort. Now Miami Beach was a heavy hitter and art collectors like the Rubell family were justified in positioning themselves in this tropical location. Major galleries from all over the world came to show off their wares in the Miami Beach Convention Center. A line up of container vessels, or Art Positions, along the beachfront nearby gave emerging artists a place to display their work.

Left: A Venetian flourish on the Edison Hotel.
Opposite: Jeanne Claude and Christo's Surrounded Islands project.

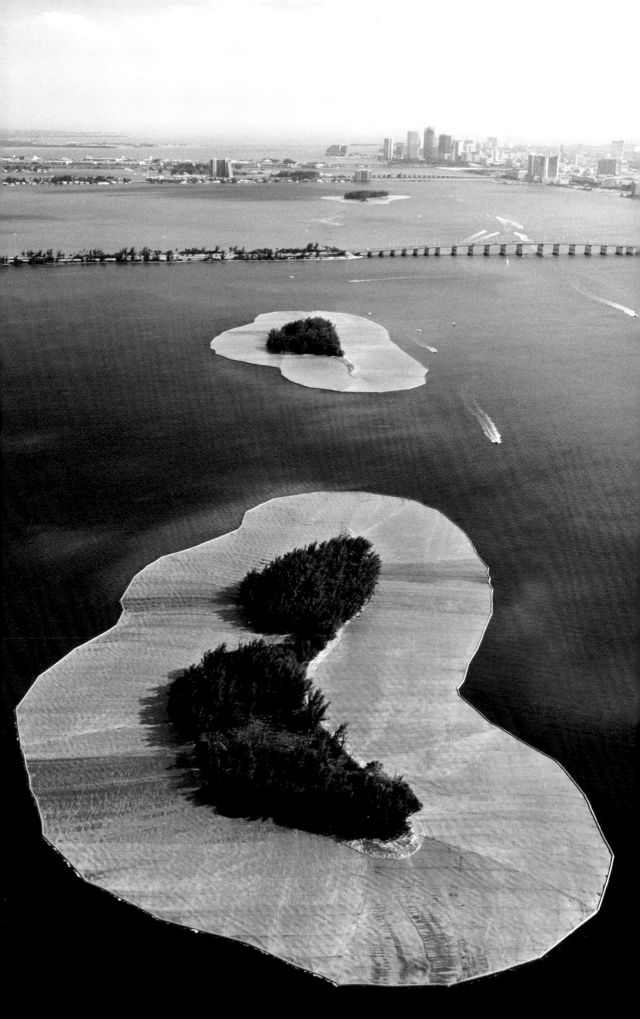

With an ever-growing mix of galleries and collectors sprinkled around the city, Miami Beach has also welcomed other arts. The Miami City Ballet, once located in a storefront on Lincoln Road, now has large and lavish digs slightly farther up the island and boasts a national reputation for their Balanchine repertoire, peppered with Latin American-inspired productions. All of this is under the direction of Edward Villela, a former New York City Ballet star. The Miami Contemporary Dance Company and its accompanying school feature modern dance under the direction of Ray Sullivan.

The New World Symphony and its acclaimed director, Michael Tilson Thomas, are yet another rich attaction. Housed on Lincoln Road in the Lincoln Theater and in the process of building larger premises nearby, the Symphony's performances are as well patronized as the openings of new nightclubs and restaurants. Leave it to Miami Beach to find more and more ways to have fun.

Opposite: Artist Jack Pierson's *Paradise* (top)
and Art Basel's Art Positions (bottom).
Above: The Jackie Gleason Theater.

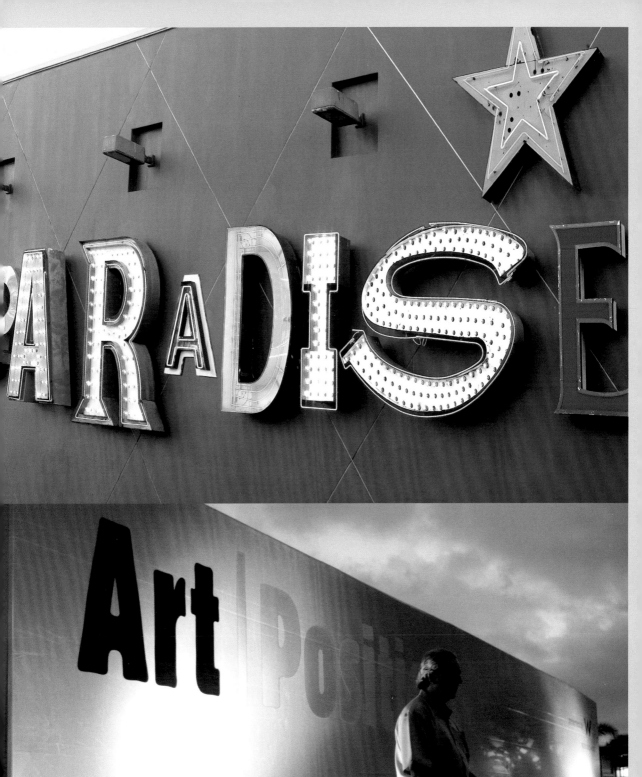

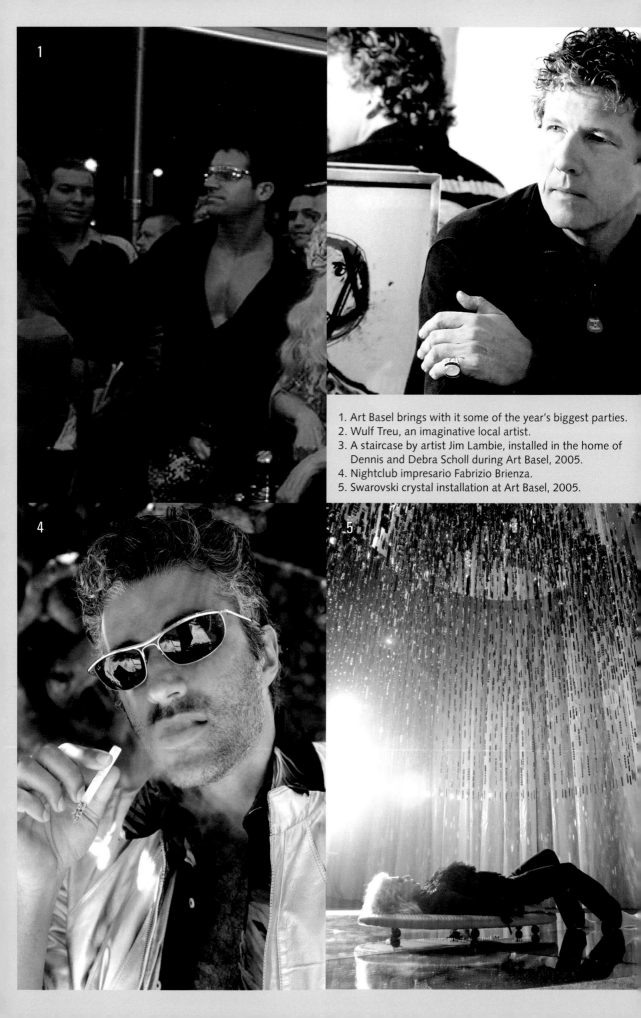

1. Art Basel brings with it some of the year's biggest parties.
2. Wulf Treu, an imaginative local artist.
3. A staircase by artist Jim Lambie, installed in the home of Dennis and Debra Scholl during Art Basel, 2005.
4. Nightclub impresario Fabrizio Brienza.
5. Swarovski crystal installation at Art Basel, 2005.

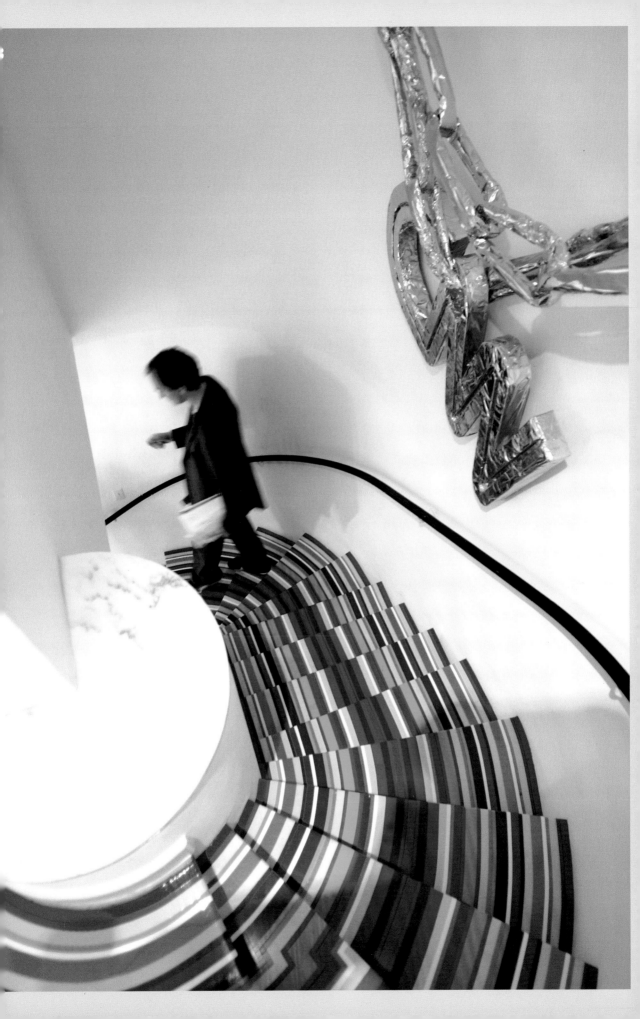

The coming of Gianni Versace to the beach in 1992 was another major step toward revitalization—not to mention an event that raised communal self-esteem. Versace bought the Amsterdam Palace, originally called Casa Casuarina, a sizable 1920s apartment building smack on Ocean Drive facing the Atlantic. The Amsterdam Palace was built to contain a lavish apartment for its wealthy owner and was modeled on the Spanish Baroque home of Christopher Columbus in Hispaniola. The wooden front door alone stands three or four times a man's height. A large bronze female nude beckons from the terrace, and the roof features an observatory. Versace bought the building for approximately $2 million—the price of a generous condo today. After his death, it changed hands for almost $20 million.

Versace made luxurious renovations and bought a lackluster 1940s hotel next door, which he tore down to install an oversized swimming pool surrounded by towering walls and large trees. Parties abounded, and being invited to them was a sign of cachet. Gianni himself could be seen ankling down Ocean Drive in

Left and opposite: Art Deco shapes and colors often serve as the backdrop for fashion shoots.

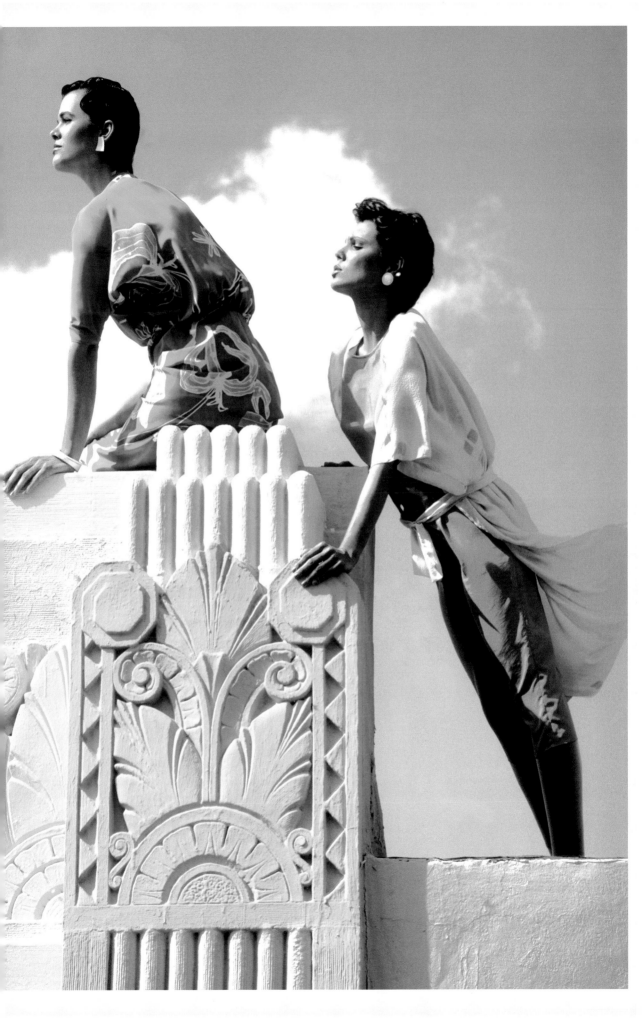

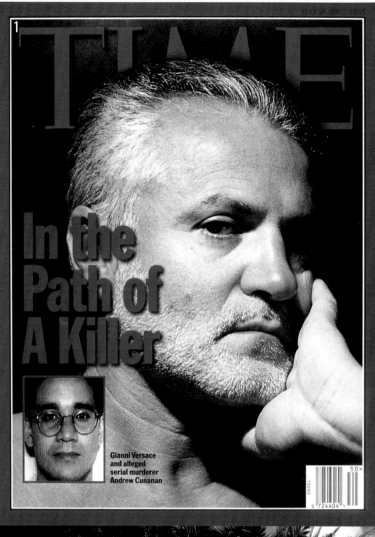

TIME

JULY 28, 1997 $3.95

In the Path of A Killer

Gianni Versace and alleged serial murderer Andrew Cunanan

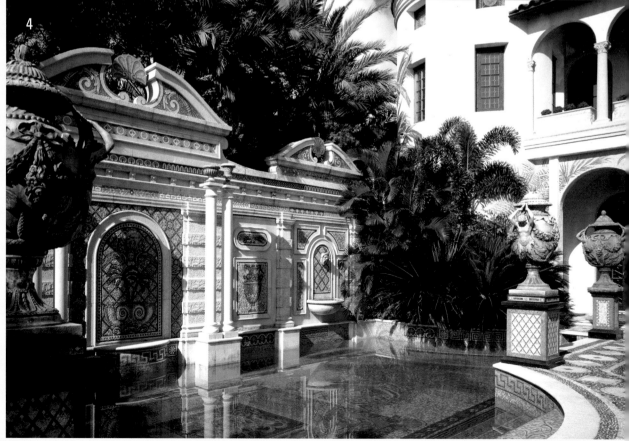

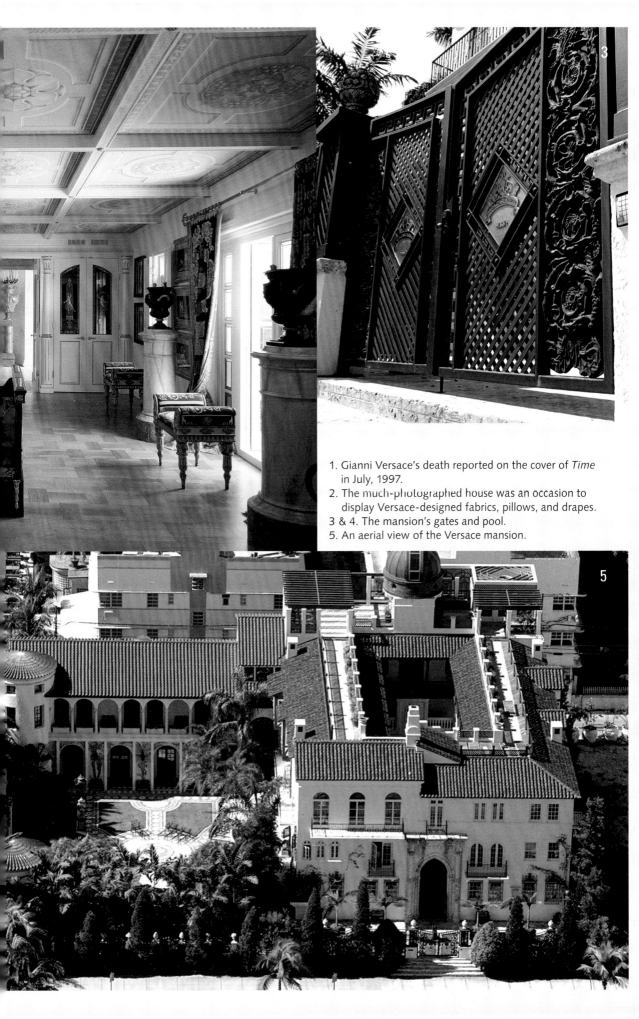

1. Gianni Versace's death reported on the cover of *Time* in July, 1997.
2. The much-photographed house was an occasion to display Versace-designed fabrics, pillows, and drapes.
3 & 4. The mansion's gates and pool.
5. An aerial view of the Versace mansion.

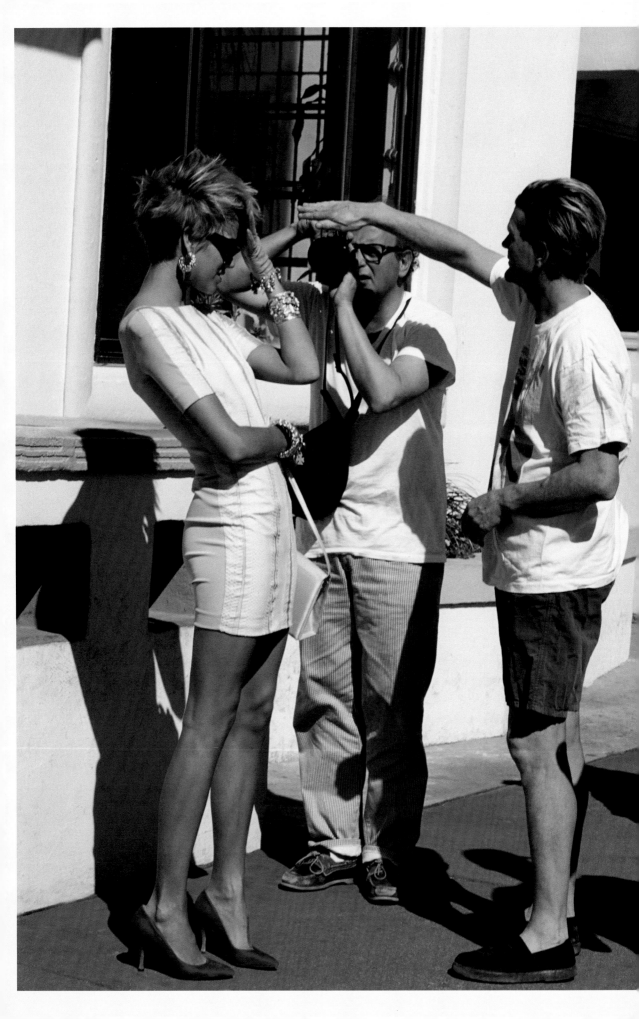

the morning to buy a paper at the News Café just down the street. He was installed in his grand new home with his sister, Donatella, and her family, whose husband, an American model, was rumored to have had a relationship with her brother that was more than casual. Such is the nature of Miami Beach gossip.

The house became a frequent tourist stop, a Versace store was installed on Washington Avenue, and all was gala until Versace was shot in cold blood on its steps as he returned from buying the morning paper on July 15, 1997. The supposed murderer, Andrew Cunanen, was surrounded on a houseboat moored in Indian Creek opposite the Fountainebleau Hotel. When the police entered, they found a suicide. The body was never identified to the satisfaction of the press or the populace and, as with much that occurs in Miami Beach, the event was swathed in mystery.

Although the Versace house has changed hands several times since, it is still commonly known by the designer's name. And despite the tragedy, having the Versace legend as part of Miami Beach history has added fashion to the city. Many of the stores along Ocean Drive, Collins Avenue, Washington Avenue, and Lincoln Road present the foremost of all fashion edges in their windows. And Miami Beach is also the home for highly original concept stores like those of Tomas Maier and Base. Maier's glittering store, installed in a shining white house, contains not only his own swimwear and clothing line but is also home to the most stylish and supremely fashionable designer frocks, sunglasses, and shoes, a trendy bookstore, and even an art gallery. All items are handpicked by the talented Maier.

Base, on Lincoln Road, is the creation of Steven Giles and Bruce Canella. Giles designs all of the ahead-of-everyone clothing in the store, and you can also can buy shoes, books, the latest CDs, and even get a haircut. A customer can leave this store, and subsequently Miami, a transformed person.

Photographer Arthur Elgort and stylist Christian on a local photo shoot.

MIAMI BEACH IS BACK

Today, Miami Beach is back—in an almost unrecognizable form. This isn't the careful restoration of a faded beauty, but more the image of a daughter, young and energetic and in many ways completely different from her predecessor. The Miami Design Preservation League energized the community to value its Art Deco District, and by the end of the 1980s, Miami Beach had garnered a reputation as an artistic bohemia. A place where new fashion, new art, and new kinds of restaurants and nightclubs were beginning to emerge. All in a truly international way.

German catalogs were sending over teams of models and photographers, model agencies were moving in, many of the Art Deco buildings had been repainted, and photos of these imaginative new looks were reaching not only the country but the entire world. There was a power emanating from the beach, but it was the power of youth and beauty.

It became rare to take a stroll around town without running into a photography session. Because of the eternal summer, the northern cities of both the United States and Europe now dispatch their fashion troops to Miami Beach all winter long. Every major modeling agency has a branch somewhere near either Ocean Drive or Lincoln Road. And this is not to mention the seemingly daily influx of models cramming the sidewalks and nightclubs,

Miami Beach resident Beyonce Knowles.

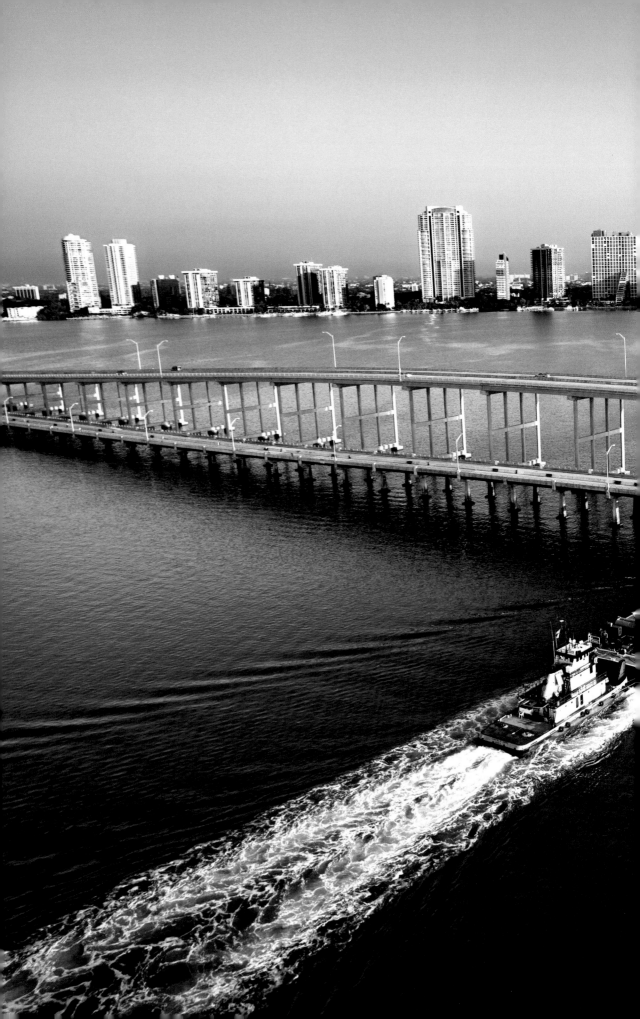

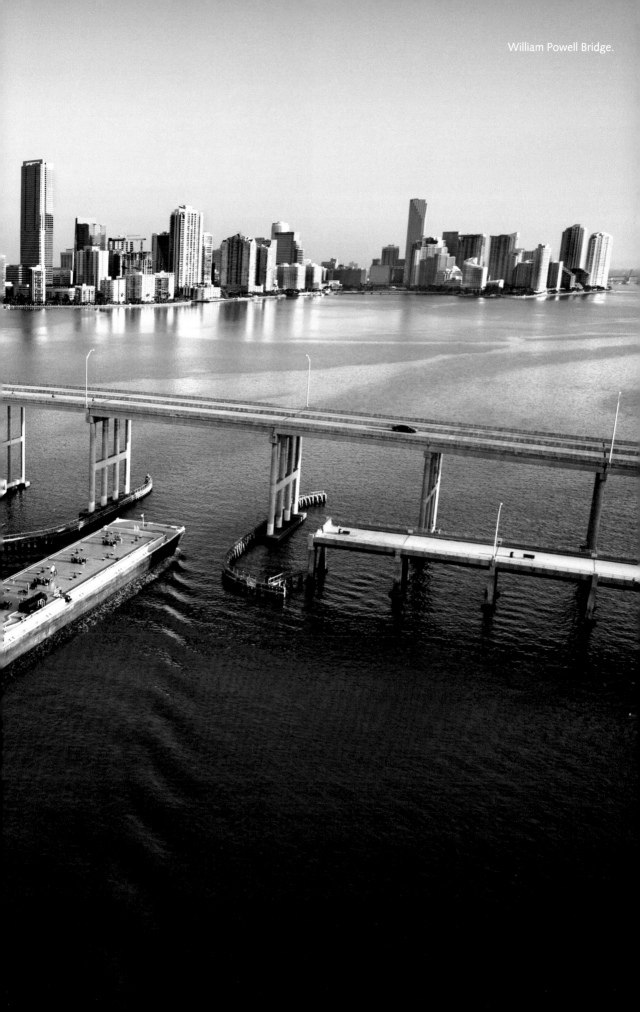

William Powell Bridge.

who come from as far away as the Ukraine and as close as Alabama to launch their careers.

Money isn't the point. Nightlife requires being able to stay up until dawn partying and still look great the next day. Few denizens would dare to appear on the beach unaccompanied by their own great bodies. The depth and strength of superficiality first became evident in Miami Beach, and now has spread to all points of the globe.

The hereditary genes of diversity and acceptance emerged, too. Whether you were gay or not; whether you were white, black, Asian, Indian, you name it; whether you were from Lebanon or Peru or Milwaukee, none of that mattered. What mattered was, "How do you look?" "Are you fun?"

Miami Beach emerged from its past presenting an even playing field for long-legged beauties and well-muscled young men from anywhere and everywhere. Your salesgirl on Lincoln Road might well be from Lithuania, your waiter from Patagonia. An

Revelers at *Ocean Drive* magazine's Volleypalooza, an annual volleball tournament exclusively for models.

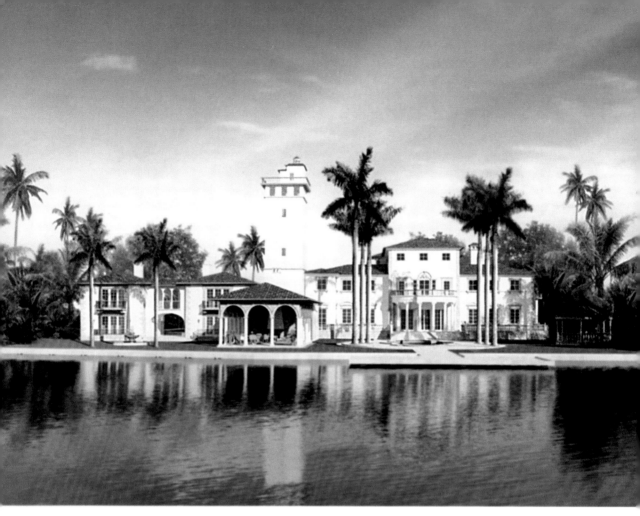

Opposite: The Miami Beach dream: a yacht, pool, and waterfront property.
Above: A rendering of a redesign for Carl Fisher's home on Indian Creek.

entire way to view the world has emerged here in Miami Beach. At night, the gorgeous people are out and about in sexy nightclubs and restaurants. During the day, the sweeping beaches receive their well-bronzed bodies. Where there was once only an active winter season, Miami Beach is now full of life and cars and money all year round.

Historically, Miami Beach has always been somewhat out of synch with the rest of the country. Today the lifestyle it offers an international clientele may very well exempt it from the financial and social downturns and upturns that sweep across other parts of the world. At this moment in time, Miami Beach is one of the most glamorous and exciting places in the world. That is, if you don't wish to be just an onlooker but rather a player. President Harry Truman once said, "If you can't take the heat, stay out of the kitchen." A Miami Beach personality would say, "If you can't handle the pace, you might as well leave town!"

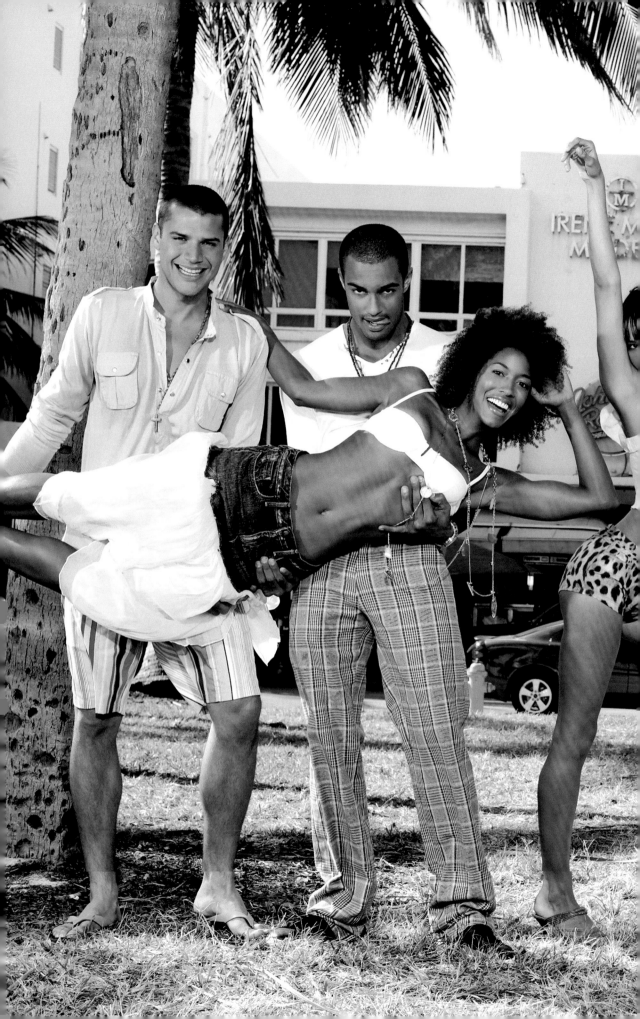

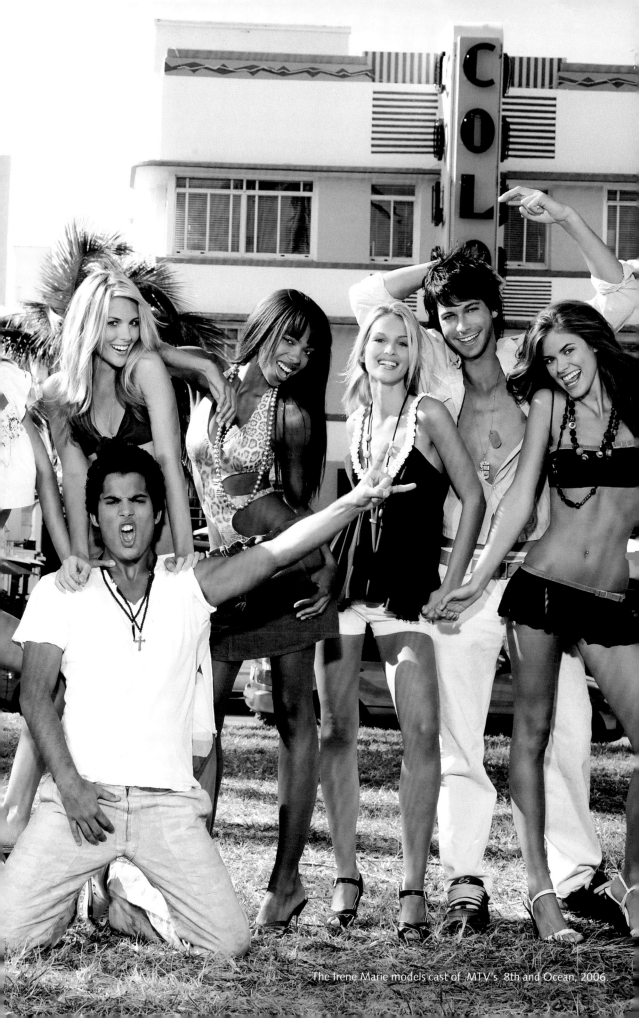

The Irene Marie models cast of MTV's 8th and Ocean, 2006.

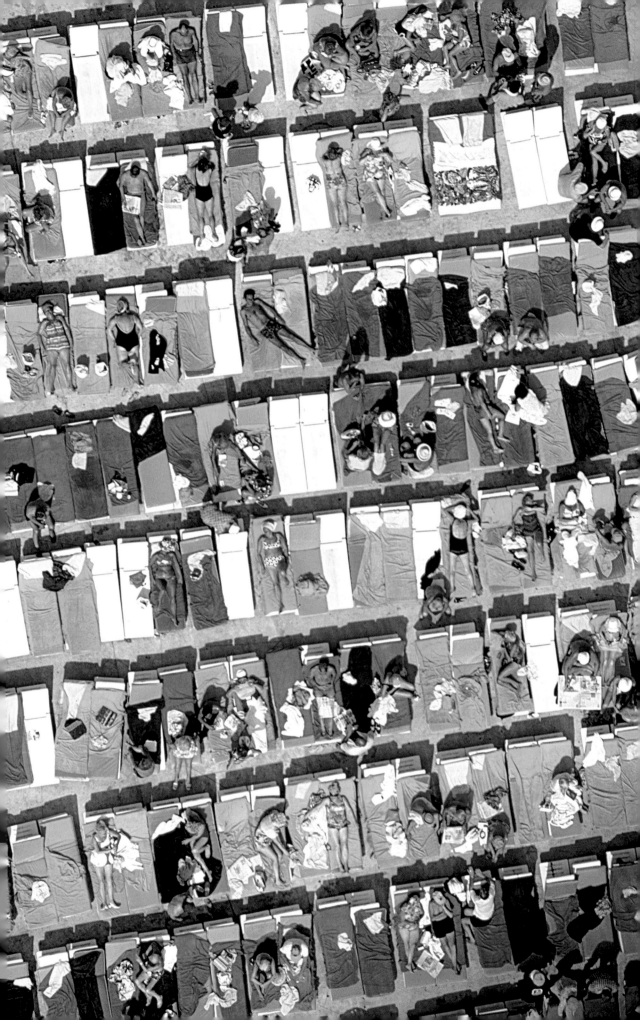

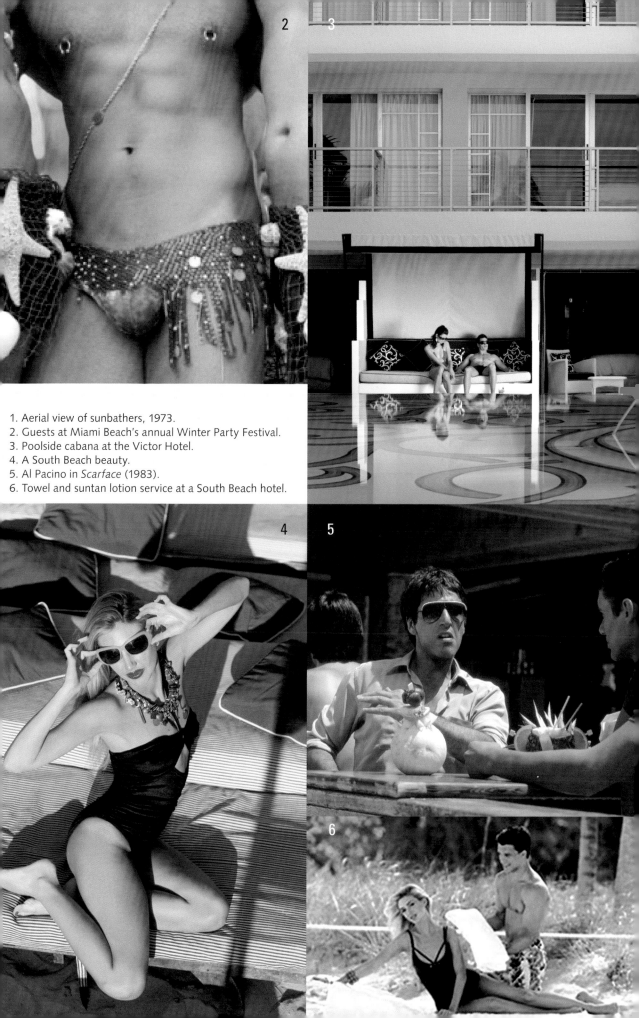

1. Aerial view of sunbathers, 1973.
2. Guests at Miami Beach's annual Winter Party Festival.
3. Poolside cabana at the Victor Hotel.
4. A South Beach beauty.
5. Al Pacino in *Scarface* (1983).
6. Towel and suntan lotion service at a South Beach hotel.

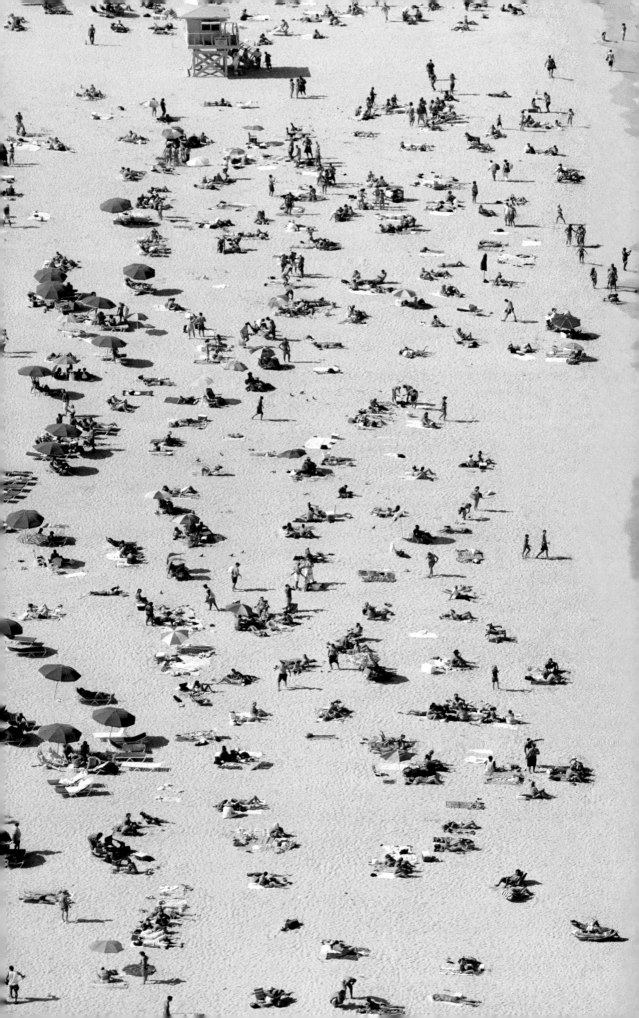

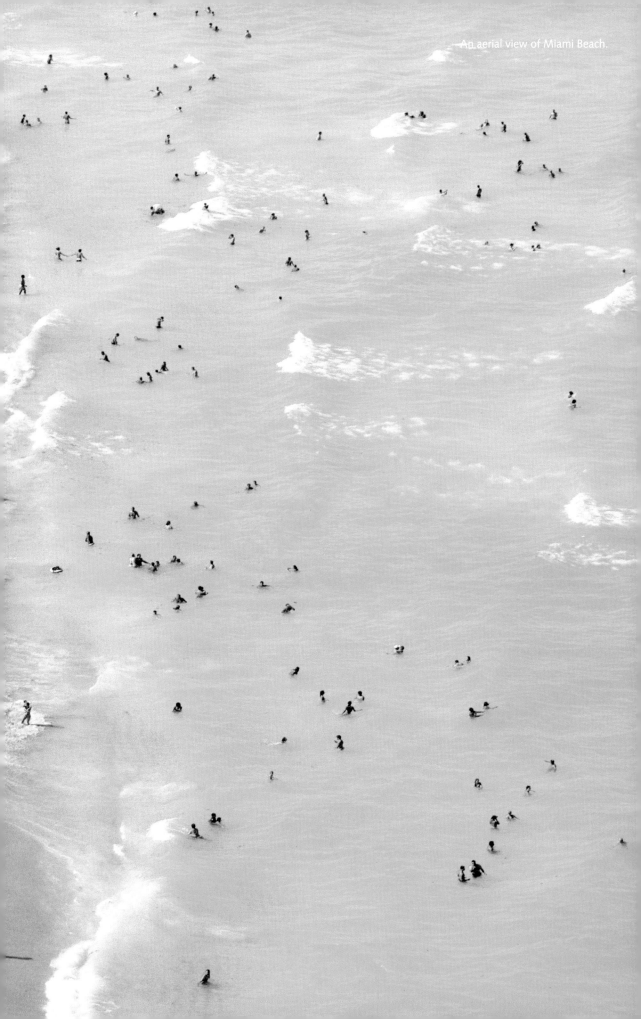

An aerial view of Miami Beach.

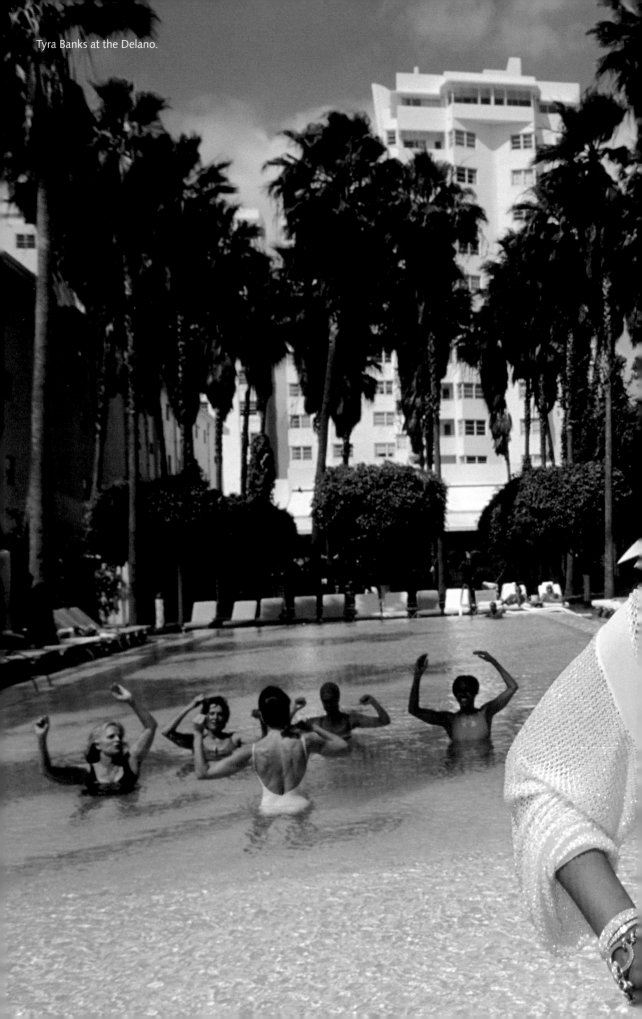

Tyra Banks at the Delano.

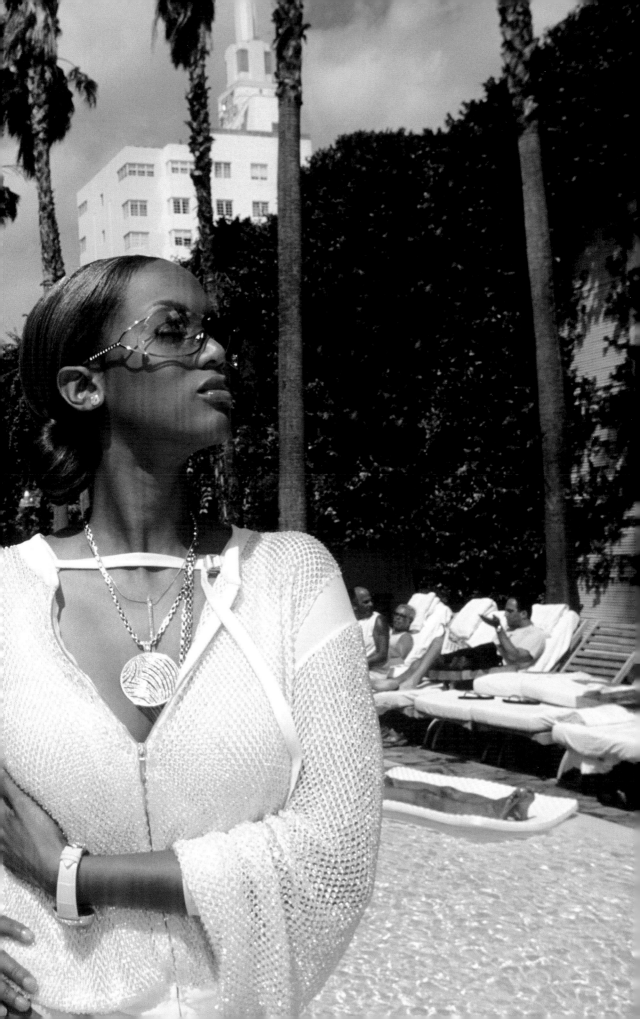

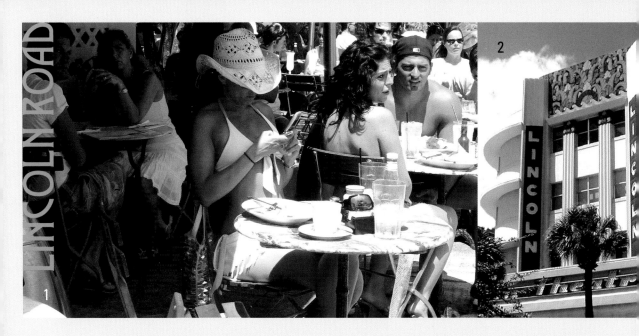

THERE ARE EARLY pictures of Lincoln Road being hacked through the mangrove swamps. In the 1920s and 1930s, it became known as the first Million Dollar Mile, with Carl Fisher's home on the ocean end and the first large hotel on the other. And soon after, jewelers, fashionable clothing shops, and even furriers took their place alongside the offices of doctors and lawyers. Miami Beach was becoming a real city, with Lincoln Road as its downtown. In the postwar period, glamour moved up the beach with the building of larger hotels like the Eden Roc. Forty-first Street was renamed Arthur Godfrey Boulevard, and restaurants and shops opened there, but Lincoln Road did not lose its allure. Cartier, Saks Fifth Avenue, and Bonwit Teller maintained their presence, and the road remained alive with shoppers and their money. Only when the population began to age and tourists sought their pleasures elsewhere did Lincoln Road begin to slide. An effort was made to revive it

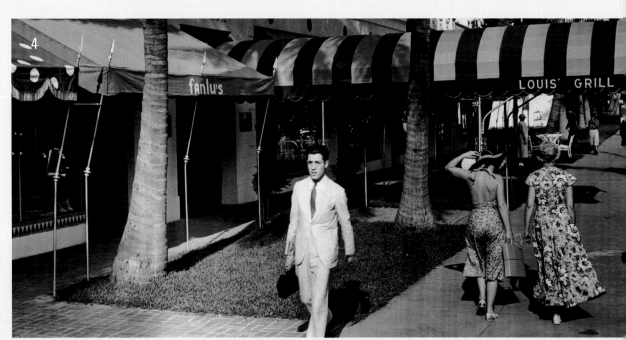

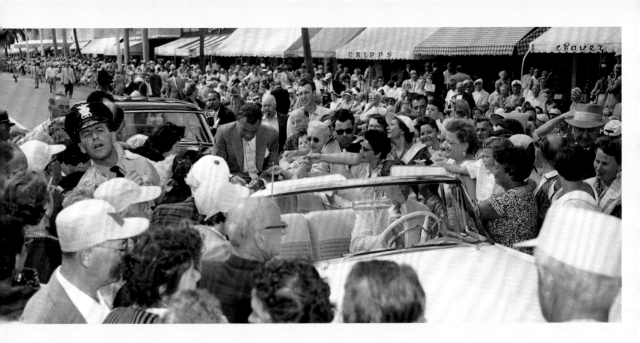

as a pedestrian walkway. By the 1980s, a cannonball could have been shot down its length and would have struck nothing. Empty stores were converted to artists' studios. And then quite suddenly Lincoln Road, was back. Where only one Cuban coffee shop with a single counter existed, now dozens of tables were being set out on the pavement. The little trolley bus that used to carry older shoppers from one end of the road to the other is gone. It can no longer make its way through the mobs, accompanied by dogs—some even on rollerblades or skateboards!—that throng the street from early in the day until late at night. This is a town where even at midnight and long after, every chair on every terrace of every restaurant, café, and bar is taken. Every shop, eatery, and bookstore has a share in the sensuous appeal of this promenade where beauty, brassiness, and the boldness of the new all come together in the delirious mix that makes Miami Beach a world of its own.

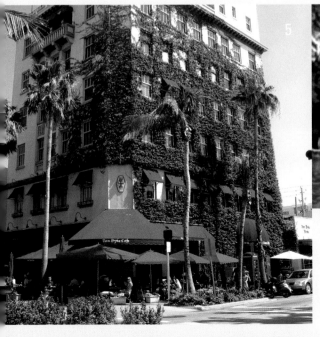

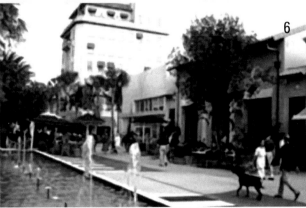

1. Lunchtime at a sidewalk café.
2. The Lincoln Theatre.
3. Ed Sullivan signs autographs, 1956.
4. Posh shops on Lincoln Road in the 1930s.
5. The Van Dyke Café.
6. Stores and cafés line Lincoln Road.

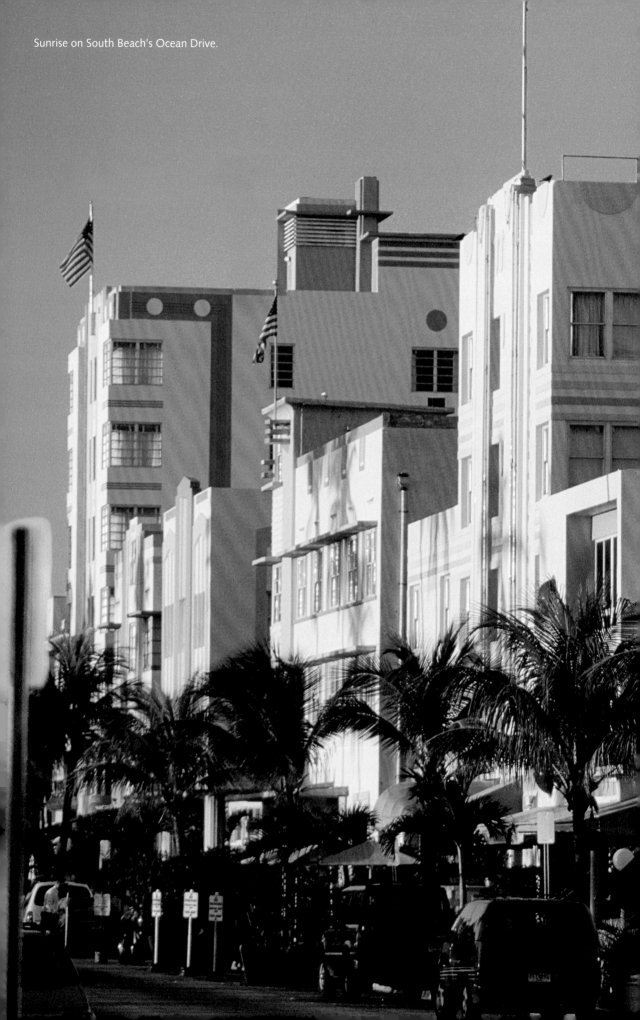

Sunrise on South Beach's Ocean Drive.

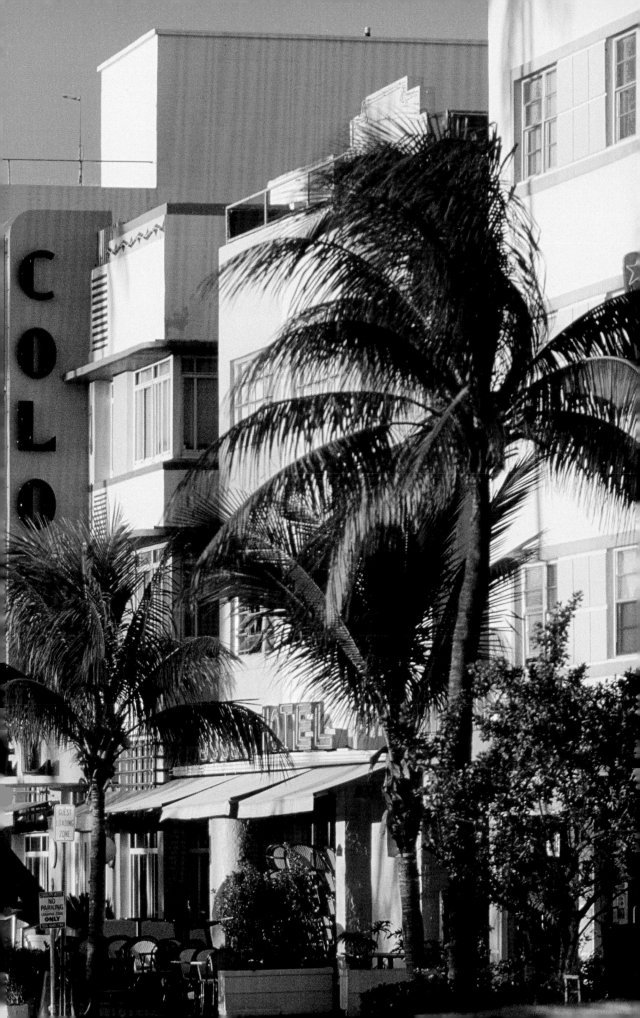

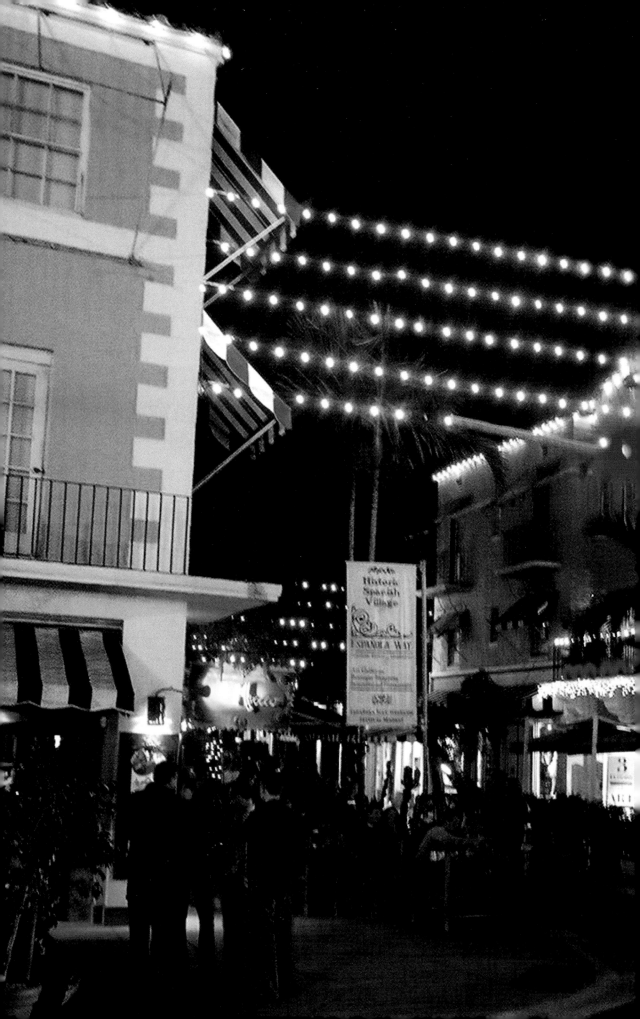

Española Way at night.

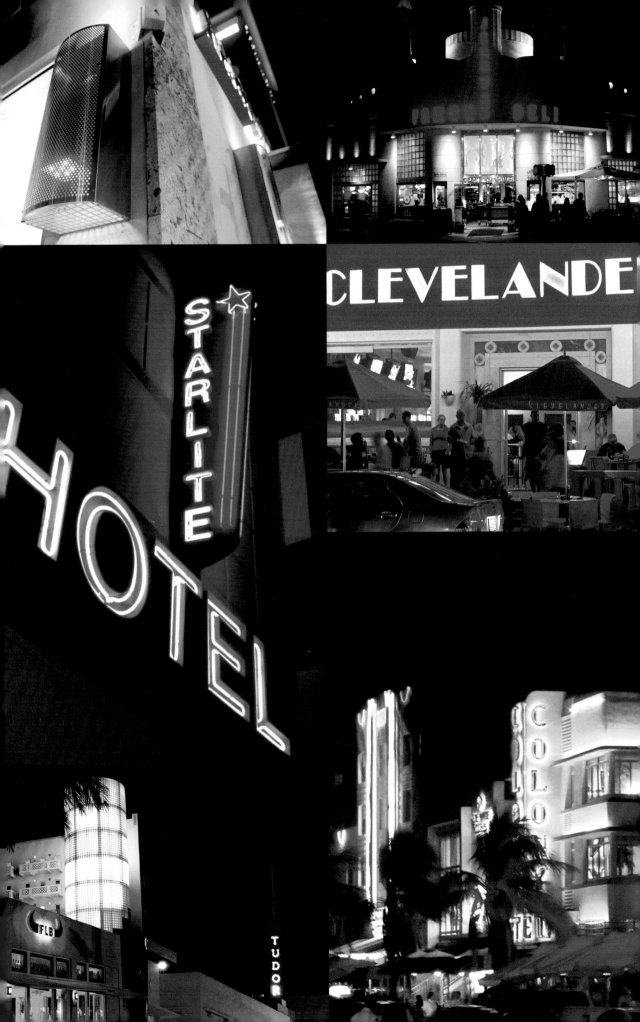

Neon lights up Miami Beach at night.

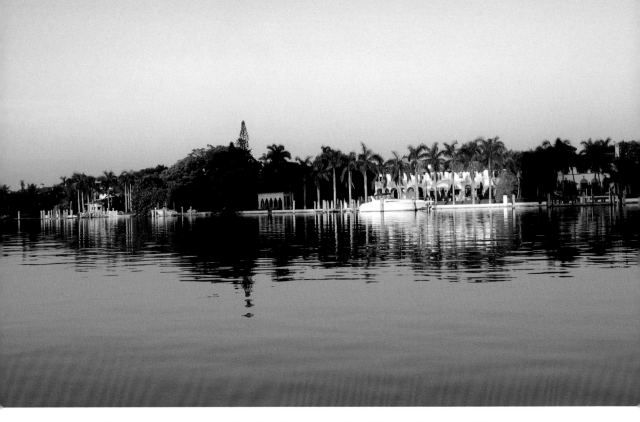

A private residence on the Venetian Islands (above), and Ocean Drive at night (opposite).

Ocean Drive is the ten-block-stretch of South Beach that runs alongside the Atlantic. The palm-tree-strewn park that sits in front of it is all that remains of the original Lummus plantation, which once extended up and down Miami Beach. After traversing this narrow plot of grass and trees, one has only the wide, wide beach to cross before reaching the turquoise green sea.

Ocean Drive bounced into being in the 1930s, when the Depression dollar no longer allowed frequent travel to Europe. Miami Beach, however, was within reach, and New Yorkers flocked down to Florida for their winter vacations. There was a building boom, Depression or not, and most of these treasured Art Deco hotels were built during those years. They make up Miami Beach's most recognizable skyline, their pastel tones rising behind the palm trees viewed from the beach.

In the 1980s, as Miami Beach was recovering from its midlife crisis, most of the hotels were inhabited by aging Central European retirees. Suddenly, the Hotel Carlyle and the Hotel Cardozo had upscale restaurants on their front porches instead of rows of aluminum chairs, and the retirees were stymied, startled—and excited. And the stampede was on.

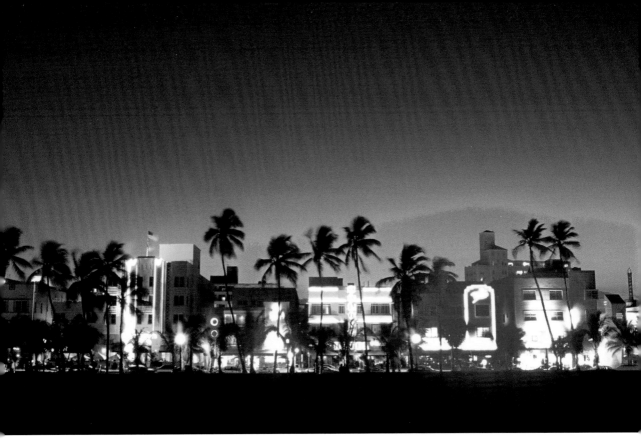

By the 1990s, most of the hotels had been smartened up, restaurants and coffee shops abounded, and much of the clientele in the eateries consisted of local people. Crowds flocked outside the News Café, hoping to secure one of the most desirable seats at the sidewalk tables, and the rubbernecking passersby clogged up the narrow path in front of it. While Ocean Drive was hopping, during the 1990s Lincoln Road still remained a shopping and dining Sahara. The Drive's Clevelander Hotel and its outdoor poolside bar became a hangout for college students to such an extent that the owners installed a small bandstand for live music, as did several other hotels up and down Ocean Drive. And nightlife got noisier, later, and—wilder.

Today Ocean Drive is a major destination for visitors. Sidewalks are jammed, every seat is taken in the wall-to-wall restaurants, and music fills the air—even at midnight. Clubs dominate the neighborhood, and on the nearby Collins and Washington avenues, nightspots like Crobar, Snatch, and Mansion rage on until dawn. In the early days, neighbors complained about the noise and an ordinance was passed. But control is impossible in Miami Beach. Ocean Drive is the heartbeat of nightlife in this town. And the beat goes on.

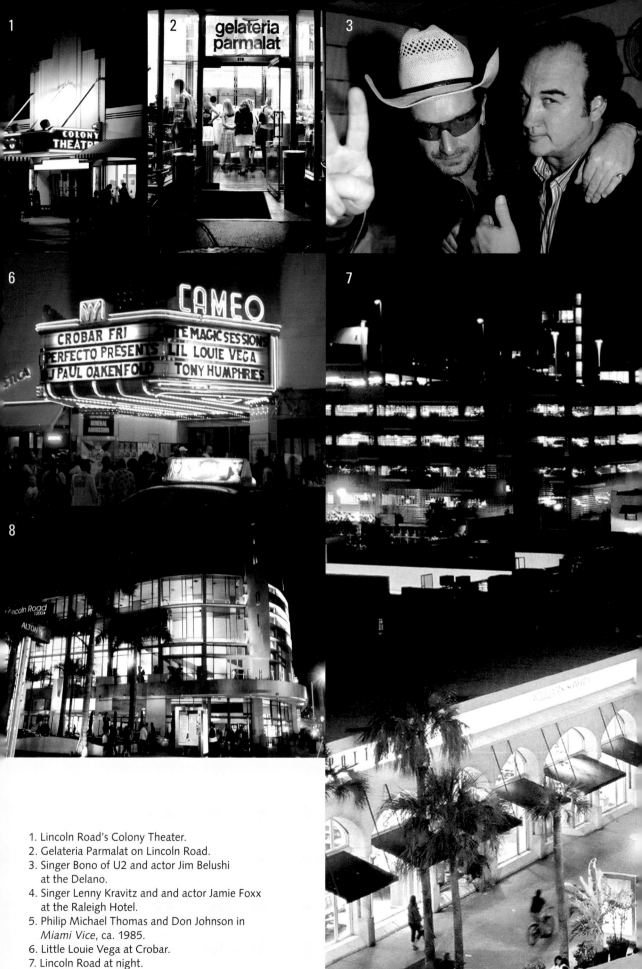

1. Lincoln Road's Colony Theater.
2. Gelateria Parmalat on Lincoln Road.
3. Singer Bono of U2 and actor Jim Belushi
 at the Delano.
4. Singer Lenny Kravitz and and actor Jamie Foxx
 at the Raleigh Hotel.
5. Philip Michael Thomas and Don Johnson in
 Miami Vice, ca. 1985.
6. Little Louie Vega at Crobar.
7. Lincoln Road at night.
8. Lincoln Drive and Alton Road.

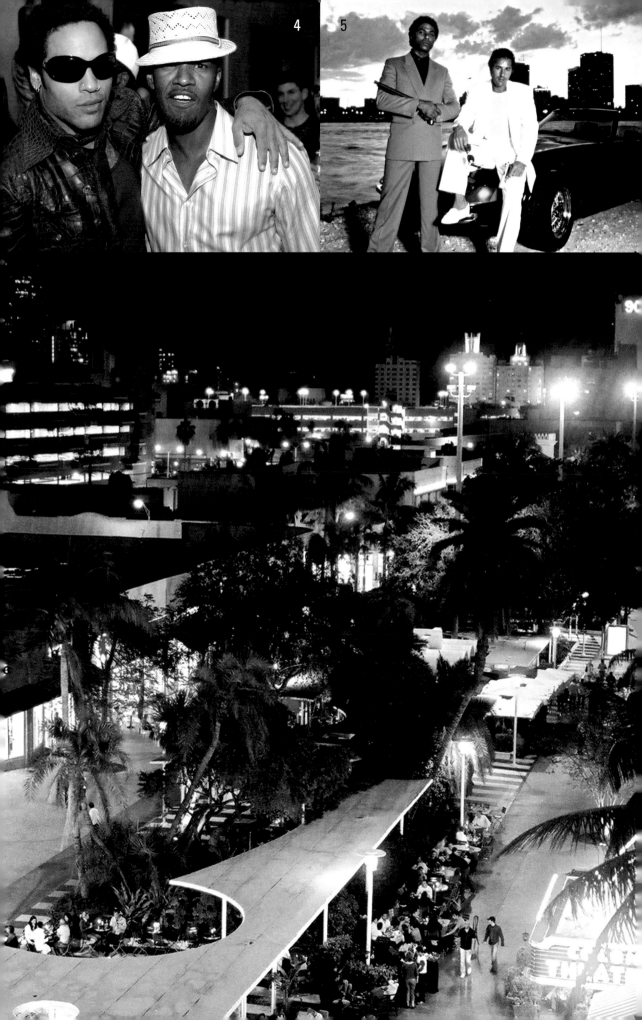

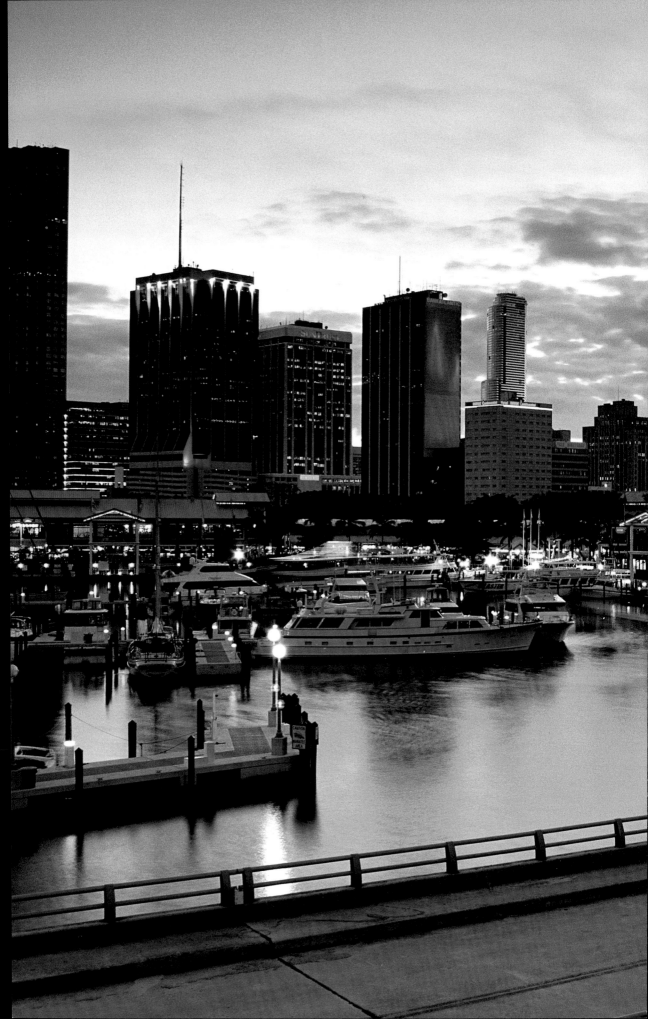

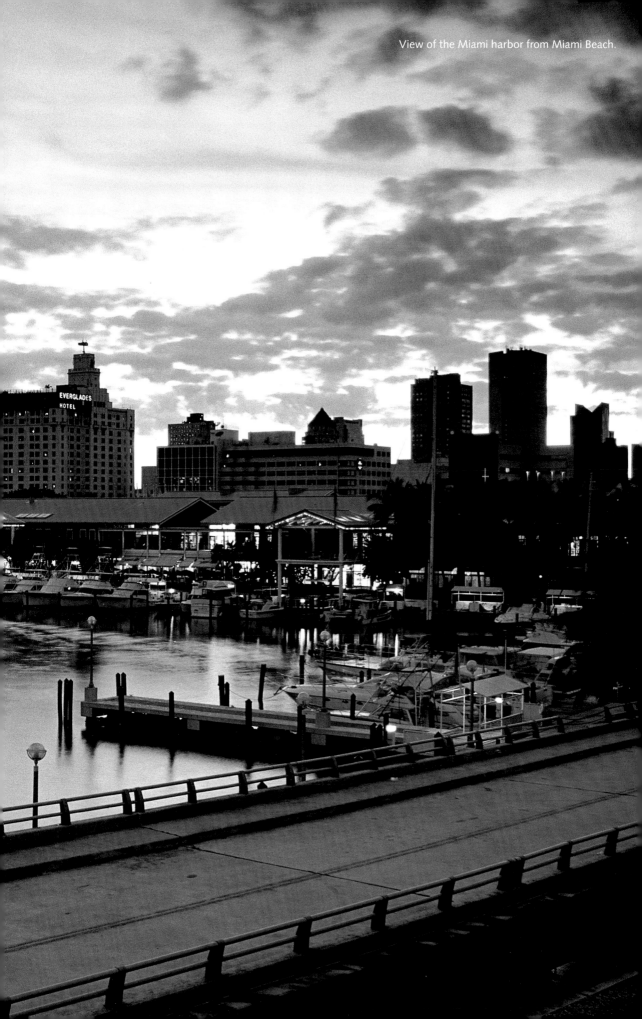
View of the Miami harbor from Miami Beach.

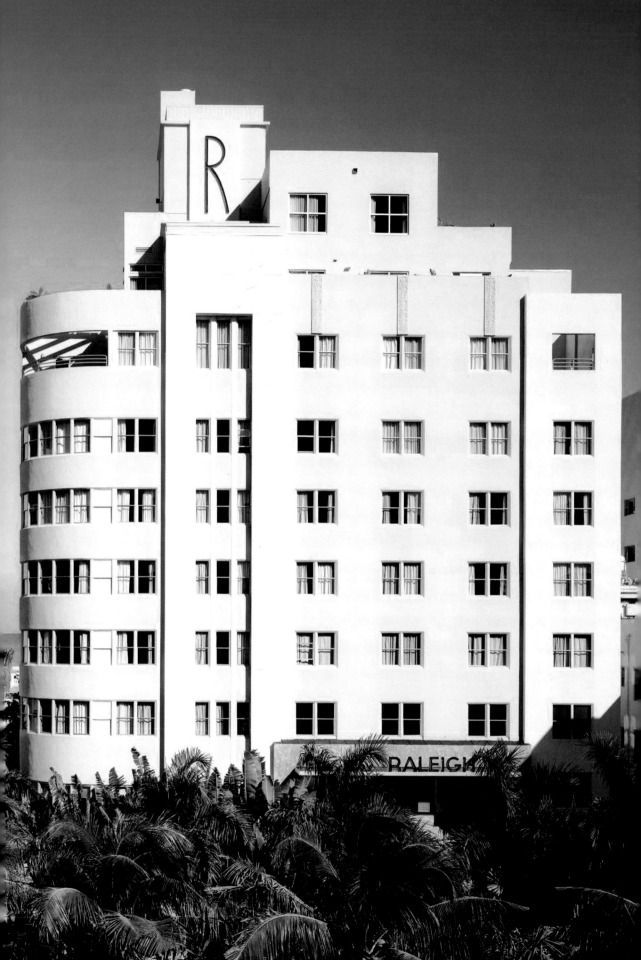

HOTELS

THE ANGLERS HOTEL
660 Washington Avenue
Miami Beach, FL 33139
305-534-9600

THE BETSY
1440 Ocean Drive
Miami Beach, FL 33139
305-531-6100

THE DELANO HOTEL
1685 Collins Avenue
Miami Beach, FL 33139
305-672-2000

THE DREAM HOTEL
1111 Collins Avenue
Miami Beach, FL 33139
305-673-4747

THE EDEN ROC RESORT AND SPA
4525 Collins Avenue
Miami Beach, FL 33140
305-531-0000

THE FONTAINEBLEAU RESORT
4441 Collins Avenue
Miami Beach, FL 33140
305-538-2000

THE GANSEVOORT HOTEL
2377 Collins Avenue
Miami Beach, FL 33139
305-604-1000

HILTON BENTLEY
SOUTH BEACH HOTEL
101 Ocean Drive
Miami Beach, FL 33139
305-938-4600

THE HOTEL
801 Collins Avenue
Miami Beach, FL 33139
305-531-3222

LORDS HOTEL
1120 Collins Avenue
Miami Beach, FL 33139
877-448-4754

THE MONDRIAN HOTEL
1100 West Avenue
Miami Beach, FL 33139
305-672-2662

THE PALMS HOTEL & SPA
3025 Collins Avenue
Miami Beach, FL 33140
305-534-0505

THE RALEIGH HOTEL
1775 Collins Avenue
Miami Beach, FL 33139
305-534-6300

RED HOTEL
3010 Collins Avenue
Miami Beach, FL 33140
305-531-7742

THE SAGAMORE HOTEL
1671 Collins Avenue
Miami Beach, FL 33139
305-535-8088

THE SETAI HOTEL
2001 Collins Avenue
Miami Beach, FL 33139
305-520-6000

THE SHORE CLUB HOTEL
1901 Collins Avenue
Miami Beach, FL 33139
305-695-3100

THE SOHO BEACH HOUSE HOTEL
4385 Collins Avenue
Miami Beach, FL 33140
786-507-7900

THE STANDARD HOTEL
40 Island Avenue
Miami Beach, FL 33139
305-673-1717

THE VILLA BY BARTON G
1116 Ocean Drive
Miami Beach, FL 33139
305-576-8003

THE W HOTEL
2201 Collins Avenue
Miami Beach, FL 33139
305-938-3000

The Raleigh.

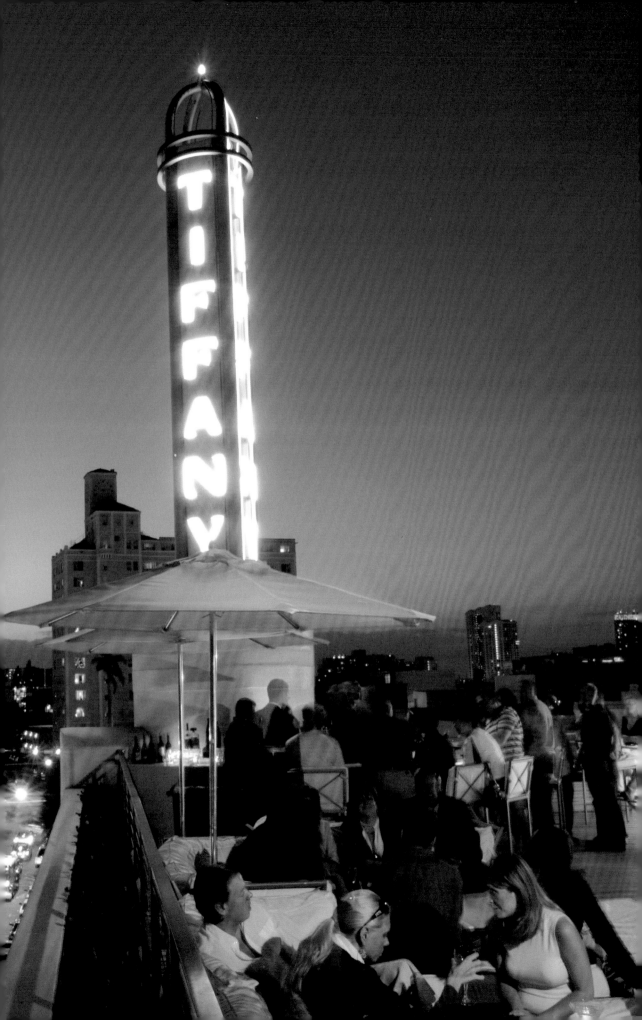

BARS & CLUBS

ARKADIA
AT THE FONTAINEBLEAU HOTEL
4441 Collins Avenue
Miami Beach, FL 33140
305-674-4680

THE BAR AND COURTYARD
AT THE SETAI HOTEL
2001 Collins Avenue
Miami Beach, FL 33139
305-520-6000

BAR 721
721 Lincoln Lane North
Miami Beach, FL 33139
305-532-1342

B.E.D.
929 Washington Avenue
Miami Beach, FL 33139
305-532-9070

CAMEO
1445 Washington Avenue
Miami Beach, FL 33139
305-532-2667

CLUB DEUCE
222 14th Street
Miami Beach, FL 33139
305-531-6200

THE FLORIDA ROOM
AT THE DELANO HOTEL
1685 Collins Avenue
Miami Beach, FL 33139
305-674-6152

HAVEN LOUNGE
1237 Lincoln Rd.
Miami Beach, FL 33139
305-987-8885

LIV AT THE FONTAINEBLEAU HOTEL
4441 Collins Avenue
Miami Beach, FL 33140
305-674-4680

MARTINI BAR AT THE RALEIGH HOTEL
1775 Collins Avenue
Miami Beach, FL 33139
305-534-1775

MOVA
1625 Michigan Avenue
Miami Beach, FL 33139
305-534-8181

MYNT LOUNGE
1921 Collins Avenue
Miami Beach, FL 33139
305-532-0727

NIKKI BEACH
1 Ocean Drive
Miami Beach, FL 33139
305-538-1111

PURDY LOUNGE
1811 Purdy Avenue
Miami Beach, FL 33139
305-531-4622

ROKBAR
1905 Collins Avenue
Miami Beach, FL 33139
305-674-4397

SCORE
727 Lincoln Rd.
Miami Beach, FL 33139
305-535-1111

SKY BAR
AT THE SHORE CLUB HOTEL
1901 Collins Avenue
Miami Beach, FL 33139
305-695-3288

TWIST
1057 Washington Avenue
Miami Beach, FL 33139
305-538-9478

V.F.W.
650 West Avenue
Miami Beach, FL 33139
305-672-1990

A rooftop party at The Hotel.

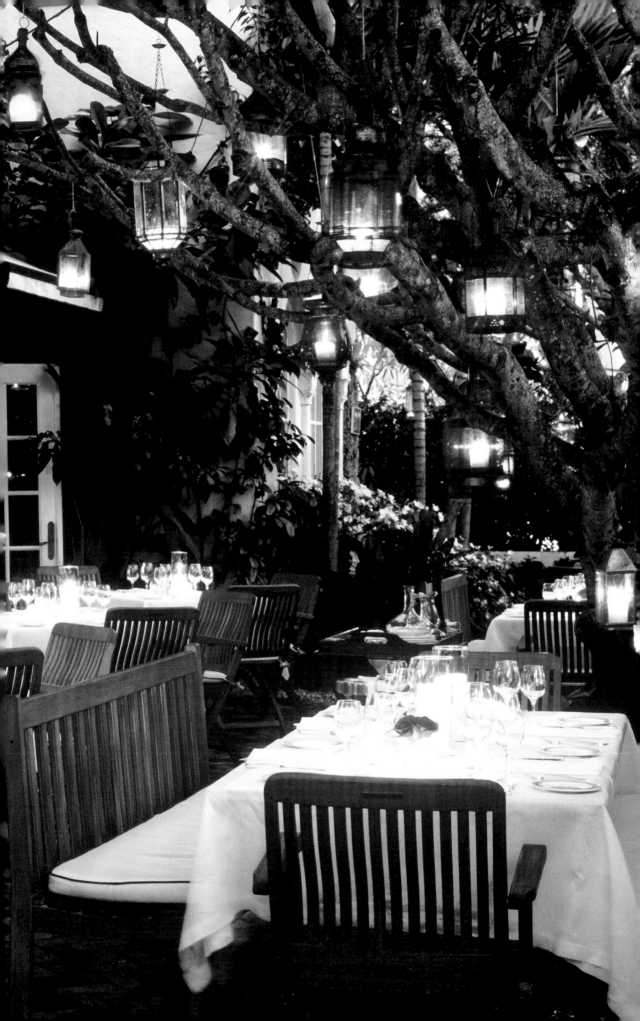

RESTAURANTS

ASIA DE CUBA AT THE
MONDRIAN HOTEL
1100 West Avenue
Miami Beach, FL 33139
305- 514-1940

BALANS
1022 Lincoln Rd.
Miami Beach, FL 33139
305-534-9191

BLUE DOOR FISH
AT THE DELANO HOTEL
1685 Collins Avenue
Miami Beach, FL 33139
305 674 6400

CAFE AT BOOKS AND BOOKS
933 Lincoln Rd.
Miami Beach, FL 33139
305-695-8898

CECCONI'S
AT THE SOHO BEACH HOUSE HOTEL
4385 Collins Avenue
Miami Beach, FL 33140
786-507-7902

GUSTO VINE E CAFFE
950 West Avenue
Miami Beach, FL 33139
305-397-8712

HAVEN
1237 Lincoln Rd.
Miami Beach, FL 33139
305-987-8885

LA FOLIE
516 Espanola Way
Miami Beach, FL 33139
305-538-4484

MEAT MARKET
915 Lincoln Rd.
Miami Beach, FL 33139
305-532-0088

MORGANS
1787 Purdy Avenue
Miami Beach, FL 33139
305-397-8753

MR. CHOW
AT THE W HOTEL
2201 Collins Avenue
Miami Beach, FL 33139
305-695-1695

OLIVER'S BISTRO
959 West Avenue
Miami Beach, FL 33139
305-535-3050

PHILLIPE
36-40 Ocean Drive
Miami Beach, FL 33139
305-674-0250

PRIME 112
112 Ocean Drive
Miami Beach, FL 33139
305-532-8112

PUBBELLY
1418 20th Street
Miami Beach, FL 33139
305-532-7555

THE ROYAL RESTAURANT
AT THE RALEIGH HOTEL
1775 Collins Avenue
Miami Beach, FL 33139
305-534-6300

RED STEAK HOUSE
119 Washington Avenue
Miami Beach, FL 33139
305-534-3688

SAVARIN
Bal Harbour Shops
9700 Collins Avenue
Bal Harbour, FL 33154
305-868-0655

STK
AT THE GANSEVOORT HOTEL
2377 Collins Avenue
Miami Beach, FL 33139
305-604-1000

WINE DEPOT
555 Jefferson Avenue
Miami Beach, FL 33139
305-672-6161

Outdoor dining at Casa Tua.

SPAS & SPORTS

BIKE, CAR, SEGWAY & SCOOTER RENTALS RENTALS

DECO BIKE MIAMI BEACH
Bike Sharing & Rental Program
Various locations throughout Miami Beach
723 Washington Avenue
South Beach, FL 33139
305-532-9494

GOCAR TOURS MIAMI
1655 James Avenue
Miami Beach, FL 33139
305-908-8497

MIAMI BEACH BICYCLE CENTER
601 5th Street
Miami Beach, FL 33139
305-531-4161

SCOOTER CITY
711 Washington Avenue
Miami Beach, FL 33139
305-532-2032

233 14th Street
Miami Beach, FL 33139
305-673-3322

SEGWAY EXPERIENCE AT SOUTH BEACH
1655 James Avenue
Miami Beach, FL 33139
786-290- 0599

FISHING

BISCAYNE FISHING GUIDE
1113 N.W. 172 Avenue
Pembroke Pines, FL 33029
786-412-4859

PIER 5 FISHING CHARTERS
Bayside Marina
401 Biscayne Boulevard
Miami, FL 33132
305-379-5119

TROPICAL BOAT TOURS
Call to schedule a pick-up
786-218-3030

GOLF

BAYSHORE PAR 3
Free 9-hole public course in Miami Beach
2795 Prairie Ave
Miami Beach, FL 33140
305-674-0305

MIAMI BEACH GOLF CLUB
2301 Alton Rd.
Miami Beach, FL 33140
305-532-3350

GYMS

CRUNCH FITNESS
1259 Washington Avenue
Miami Beach, FL 33139
305-674-8222

1676 Alton Rd.
Miami Beach, FL 33139
305-531-4743

DAVID BARTON GYM
Gansevoort South
2323 Collins Ave
Miami Beach, FL 33139
305-534-1660

EQUINOX
520 Collins Avenue
Miami Beach, FL 33139
305-673-1172

SOUTH BEACH ACTIVE
1400 Alton Rd.
Miami Beach, FL 33139
305-909-6788

PARASAILING

BOUCHER BROTHERS
Fountainebleu Resort
4441 Collins Avenue
Miami Beach, FL 33140
305-535-8177

TENNIS

FLAMINGO PARK
11th Street & Jefferson
Miami Beach, FL 33139
305-673-7761

SURFSIDE TENNIS CENTER
8750 Collins Avenue
Surfside, FL 33154
305-866-5176

SCUBA DIVING

SOUTH BEACH DIVERS
850 Washington Avenue
Miami Beach, FL 33139
305-531-6110

TARPOON LAGOON
300 Alton Road - Suite 110
Miami Beach, FL 33139
305-532-1445

SPAS

THE STANDARD SPA
40 Island Avenue
Miami Beach, FL 33139
305-673-1717

WAVE RUNNER RENTALS

MIAMI BEACH MARINA
300 Alton Rd.
Miami Beach, FL 33129
305-538-7549

BOUCHER BROTHERS
Fountainbleu Resort
4441 Collins Avenue
Miami Beach, FL 33140
305-535-8177

JET SKI TOURS OF MIAMI
1655 James Avenue
Miami Beach, FL 33139
305-538-7547

YACHTS AND BOATS

SOUTH BEACH BOAT RENTALS
1635 North Bay Shore Drive
Miami, FL 33132
305-673-6555

SOUTH BEACH KAYAK
1771 Purdy Avenue
Miami Beach, FL 33139
305-332-2853

YOGA

BIKRAM YOGA
235 11th Street
Miami Beach, FL 33139
305-534-2727

GREEN MONKEY YOGA
1827 Purdy Avenue
Miami Beach, FL 33139
305-397-8566

SYNERGY YOGA
435 Española Way
Miami Beach, FL 33139
305-538-7073

YOGA
AT THE STANDARD SPA
40 Island Avenue
Miami Beach, FL 33139
305-673-1717

Following page: Illustration by Mary Lynn Blasutta.

Southern florida

STORES

CLOTHING

ALCHEMIST
438 Lincoln Rd.
Miami Beach, FL 33139
305-531-4653

1111 Lincoln Rd.
Carpark Level 5
Miami Beach, FL 33139
305-531-4815

BAL HARBOUR SHOPS
9700 Collins Avenue
Bal Harbour, FL 33154
305-866-0311

BASE
939 Lincoln Rd.
Miami Beach, FL 33139
305-531-4982

MADEWELL
714 Lincoln Rd.
Miami Beach, FL 33139
305-534-8079

OSKLEN
1111 Lincoln Rd.
Miami Beach, FL 33139
305-532-8977

VINTAGE CLOTHING

CONSIGN OF THE TIMES
1635 Jefferson Avenue
Miami Beach, FL 33139
305-535-0811

FLY BOUTIQUE
650 Lincoln Rd.
Miami Beach, FL 33139
305-604-8508

GIFTS

BABALU
The Mews, 1111 Lincoln Rd.
Miami Beach, FL 33139
305-538-0777

BOHEME BOUTIQUE
939 West Avenue
Miami Beach, FL 33139
305-531-9595

OH WOW
The Standard Hotel
40 Island Avenue
Miami Beach, FL 33139
305-673-1717

SHOES

TUCCIA DI CAPRI
1630 Pennsylvania Avenue
Miami Beach, FL 33139
305-534-5865

JEWELRY

CAMILLE & LUCIE
830 Lincoln Rd.
Miami Beach, FL 33139
305-397-8013

GLASSES

SEE
921 Lincoln Rd.
Miami Beach, FL 33139
305-672-6622

FURNITURE

NEST
1020 Lincoln Rd.
Miami Beach, FL 33139
305-672-9611

BOOKSTORES

BOOKS AND BOOKS
927 Lincoln Rd.
Miami Beach, FL 33139
305-532-3222

9700 Collins Avenue
Bal Harbour, Florida 33154
305-864-4241

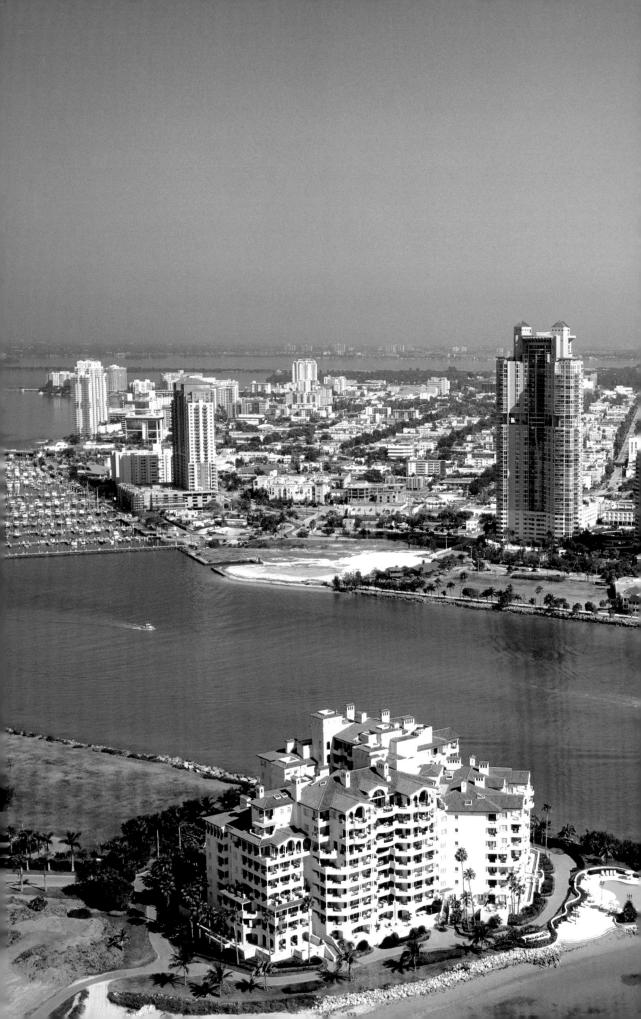

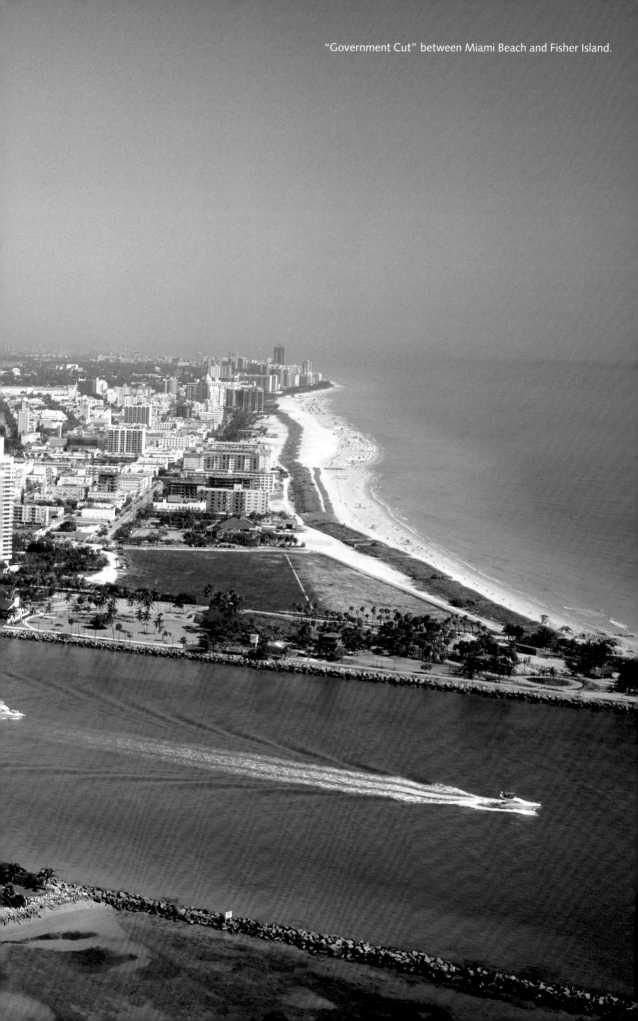

"Government Cut" between Miami Beach and Fisher Island.

BIBLIOGRAPHY

The Journal of Decorative and Propaganda Arts, "Florida" Issue 23, the Wolfsonian-Florida International University, Miami Beach, Fla.

The Life and Times of Miami Beach. Ann Armbruster. Alfred A. Knopf. New York. 1995.

The Making of Miami Beach: 1933–1941 : The Architecture of Lawrence Murray Dixon. Rizzoli. New York. 2001.

Miami Beach: A History. Howard Kleinberg. Centennial Press. Miami, FL. 1994.

Miami Beach, Images of America. Seth Bramson. Arcadia Publishing. Charleston, SC. 2005.

Miami: Hot and Cool. Laura Cerwinske. Photographs by Steven Brooke. Clarkson Potter. New York. 1990.

Miami In Vintage Postcards. Patricia Kennedy. Arcadia Publishing. Charleston, SC. 2000.

Miami, Then and Now. Arva Moore Parks and Carolyn Klepser. Thunder Bay Press. San Diego, CA. 2003.

Morris Lapidus. Deborah Desilets. Assouline. New York. 2005.

Old Florida: Florida's Magnficent Homes, Gardens, and Vintage Attractions. Patrick Smith. Photographs by Steve Gross and Sue Daley. Rizzoli. New York. 2003.

South Beach Architectural Photographs: Art Deco to Contemporary. Paul Clemence, Michael Hughes. Schiffer Publishing. Atglen, PA. 2004.

South Beach Deco: Step by Step. Iris Garnett Chase. Photographs by Susan Russell. Schiffer Publishing. Atglen, PA. 2004

ACKNOWLEDGMENTS

My most important thanks must go to my nephew Ethan Winslow, who did the photo research, took many of the contemporary photographs, and served as liason with thc publisher. This book wouldn't have happened without him.

The help of Liliam R. Hatfield at the City of Miami Beach City Clerk's Office was very much appreciated. She knows her photographs and has them. Equal thanks to the Historical Museum of Southern Florida, which has a formidable photo collection also

The terrific architecture photographer Ken Hayden contributed many excellent photos and the great fashion/beauty photographer David Vance did the same. Thanks very much to both.

For art, thanks goes to the very talented Barry Zaid for his beautiful drawings and access to his historical postcard collection, and to Michael Glidden for his postcards also.

Robert Reilly provided access to his large family collection. Rachel Ivers was helpful at the Bass Museum. And many thanks also to the ladies and gents of the many hotels, restaurants, and clubs who provided information and photos: Vanessa Menkes for Opium, Mansion, and Privé; Jennifer Foley for the Delano and The Shore Club; Martin Larson of the Sagamore; Nadine Johnson for The Raleigh and The Standard; Meredith Israel of the Victor; Devyani Singh of The Setai; and Beth Nelson of the Eden Roc.

Thanks to *Ocean Drive* and *Inside Out* magazines for helping with the photo research. And to Petra Mason and Brian Theis for their photos, and Deborah Desilets and Ilonka Sigmund for permissions.

And of course, I want to express my pleasure in working with my editor Esther Kremer of Assouline. She is quick, smart, remains cool under pressure, and is good-looking, too. The same can be said for Ausbert de Arce, head of the New York Assouline office, whom I know from earlier incarnations. And not to forget Martin Lavoie, production director, and Toni Ichikawa, our art director who created our "look." With all of these talented people in the boat, I believe we have created both something new and something definitive on Miami Beach, first of the 21st Century American cities.

An illustration by Ilonka Karasz, originally published on the cover of
The New Yorker, February 13, 1926.

COPYRIGHTS

Page 4: © Goldman Properties; Pages 8-9: © Owaki-Kulla/CORBIS; Page 12: © Bill Derrick/GETTY; Page 13: © Bill Derrick/GETTY; Page 16: © John Humble/GETTY; Pages 18-19: © Barry Zaid; Page 20: © Courtesy of the City of Miami Beach Historical Archives; Pages 22-23: © Petra Mason; Page 25: © Courtesy of the City of Miami Beach Historical Archives; Pages 26-27: © Courtesy of the City of Miami Beach Historical Archives; Page 29: © Historical Museum of Southern Florida; Page 31 top left: © Mary Evans Picture Library/Alamy; top right: © Courtesy of the City of Miami Beach Historical Archives; center right: © Historical Museum of Southern Florida; bottom: © Michael Glidden; Page 32: © Courtesy of the City of Miami Beach Historical Archives; Page 33: © Alan Schein Photography/CORBIS; Page 34: © Greg Young Publishing; Page 36: © Bettmann/CORBIS; Page 38-39: © Historical Museum of Southern Florida; Page 40: © Historical Museum of Southern Florida; Page 41 top left: © Courtesy of the City of Miami Beach Historical Archives; top right: © Courtesy of the City of Miami Beach Historical Archives; bottom: © Courtesy of the City of Miami Beach Historical Archives; Pages 42-43: © Historical Museum of Southern Florida; Page 44 top left: © Historical Museum of Southern Florida; top right: © Robert Reilly; center: © Historical Museum of Southern Florida; bottom: © Historical Museum of Southern Florida; Page 45 top: © Bettmann/CORBIS; bottom left: © Historical Museum of Southern Florida; bottom right: © Historical Museum of Southern Florida; Page 46: © Courtesy of the City of Miami Beach Historical Archives; Page 48: © Historical Museum of Southern Florida; Page 49: © Patrimoine Lanvin; Page 50: © Historical Museum of Southern Florida; Page 51 top left: © Historical Museum of Southern Florida; top right: © Bettmann/CORBIS; bottom left: © Historical Museum of Southern Florida; bottom right: © POPPERFOTO/Alamy; Page 52: © Bettmann/CORBIS; Pages 54-55: © Michael Glidden; Page 56: © Historical Museum of Southern Florida; Page 57: © Historical Museum of Southern Florida; Page 58 top left: © Barry Zaid; center left: © Historical Museum of Southern Florida; right: © Bettmann/CORBIS; bottom: © 2005 Getty Images; Page 59 top: © Bettmann/CORBIS; bottom left: © Photofest; bottom right: © Bettmann/CORBIS; Pages 60-61: © Patrick Ward/CORBIS; Page 62: © Brenda Ann Kenneally/Corbis; Page 63 top: © Bettmann/CORBIS; bottom left: © Bettmann/CORBIS; bottom right: © The Bettmann Archive/CORBIS; Pages 64-65: © Courtesy of the Morris Lapidus Archives; Page 66: © Courtesy Everett Collection; Page 67: © Courtesy of the Morris Lapidus Archives; Page 68: © Photofest; Pages 70-71: © 2005 Getty Images; Page: 72: © Danny Lyon/Magnum Photos; Page 73 top left: © Bettmann/CORBIS; top right: © Bettmann/CORBIS; bottom: © Bettmann/CORBIS; Page 74 top left: © Ethan Winslow; top right: © Bettmann/CORBIS; bottom: © Petra Mason; Page 75 top left: © Zoey Gato; top right: © Paul Colangelo/CORBIS; bottom left: © Petra Mason; bottom right: © Patrick Ward/CORBIS; Page 76: © Jason Penney/Ocean Drive Magazine; Page 77 top left: © Bill Wisser; top right: © Petra Mason; bottom left: © Petra Mason; bottom right: © Petra Mason; Page 78 top: © Tony Anderson/GETTY; bottom left: © Petra Mason; bottom right: © Petra Mason; Page 79 top right: © Jeffery Allan Salter/CORBIS SABA; bottom: © Jurgen Vogt Photography; Pages 80-81: © Bettmann/CORBIS; Page 82: © Patrick Ward/CORBIS; Pages 84-85: © Annie Griffiths Belt/CORBIS; Pages 86-87: © L. Clarke/CORBIS; Page 88 top left: © Sandra Baker/Alamy; top right: © Andre Jenny/Alamy; bottom: © Randy Faris/CORBIS; Page 89 top: © Sandra Baker/Alamy; bottom right: © Cosmo Condina/Alamy; Page 90: © Petra Mason; Page 91: © Bettmann/CORBIS; Page 92: © Petra Mason; Page 94 top: © Brian Theis; bottom: © Courtesy of the Morris Lapidus Archives; Page 95 top left: © Courtesy of the Morris Lapidus Archives; top right: © Brian Theis; Page 96 top left: © Courtesy of the Morris Lapidus Archives; top right: © Courtesy of the Morris Lapidus Archives; bottom: © Courtesy of the Morris Lapidus Archives; Page 97: © Courtesy of the Morris Lapidus Archives; Page 98 top left: © Patrick Ward/CORBIS; top right: © Ethan Winslow; bottom: © James Randklev/CORBIS; Page 99: © Petra Mason; Page 100: © Martin Meyer/zefa/Corbis; Page 101: © Nikolas Koenig; Pages 102-103: © Zoey Gato; Page 104: © Richard Cummins/CORBIS; Page 105: © Wolfgang Volz/laif/Redux; Page 107 top: © Ken Hayden; bottom: © Richard Patterson; Page 108 top right: © Ethan Winslow; bottom left: © Navid; bottom right: © Richard Patterson; Page 109: © Orjan F: Ellingvag/Dagens Naringsliv/Corbis; Page 110: © David Vance; Page 111: © David Vance; Page 112 top left: © Time & Life Pictures; top right: © Massimo Listri/CORBIS; bottom: © Massimo Listri/CORBIS; Page 113 top right: © Jeff Greenberg/Alamy; bottom: © Stephane Cardinale/Corbis; Page 114: © Rose Hartman/CORBIS; Page 116: © Scott Gries/Getty; Pages 118-119: © Ron Chapple/GETTY; Pages 120-121: © Lauren Greenfield/VII; Page 122: © Petra Mason; Page 123: © Haute Living Magazine; Pages 124-125: © Navid; Page 126: © James L. Amos/CORBIS; Page 127 top left: © Richard Patterson; top right: © Ken Hayden; bottom left: © David Vance; bottom right: © Photofest; Pages 128-129: © Matthias Clamer/GETTY; Pages 130-131: © Lauren Greenfield/VII; Page 132 top left: © Petra Mason; top right: © Ethan Winslow; bottom: © Historical Museum of Southern Florida; Page 133 top: © Bettmann/CORBIS; bottom left: © Petra Mason; Pages 134-135: © Patrick Ward/CORBIS; Pages 136-137: © Ethan Winslow; Page 138 all photos © Ethan Winslow; except center left: © Brian Theis; ; Page 139 top left: © Ethan Winslow; top right: © Ethan Winslow; center left: © Ethan Winslow; center right: © Ethan Winslow; center: © www.surfcomber.com; bottom center: © Brian Theis; bottom right: © Ethan Winslow; Page 140: © Petra Mason; Page 141: © Mark Bassett/Alamy; Page 142 top left: © Ethan Winslow; top center: © Ethan Winslow; top right: © www.wireimage.com; center: © 2006 Gustavo Caballero; bottom left: © Ethan Winslow; bottom right: © Ethan Winslow; Page 143 top left: © www.wireimage.com; top right: © Courtesy Everett Collection; Pages 144-145: © Richard Cummins/CORBIS; Page 146: © Nikolas Koenig; Page 148: © Richard Patterson; Page 150: © Petra Mason; Page 154: © Mary Lynn Blasutta; Pages 156-157: © Tony Arruza/CORBIS; Page 158: © Ilonka Karasz.

Publisher's note: Every possible effort has been made to identify legal claimants; any errors and omissions brought to the publisher's attention will be corrected in subsequent editions.